THE
HOLOGRAPHY
BOOK

THE HOLOGRAPHY BOOK

Jeff Berner

AVON
PUBLISHERS OF BARD, CAMELOT AND DISCUS BOOKS

For Lloyd and Sharon and Posy

Photograph of pulsed laser transmission hologram SELF-PORTRAIT AFTER ESCHER, 1978 (11″ × 14″) by Peter Nicholson. Photo © 1978 Kumar Productions.

THE HOLOGRAPHY BOOK is an original publication of Avon Books. This work has never before appeared in book form.

AVON BOOKS
A division of
The Hearst Corporation
959 Eighth Avenue
New York, New York 10019

Copyright © 1980 by Jeff Berner
Published by arrangement with the author
Library of Congress Catalog Card Number: 79-55564
ISBN: 0-380-75267-0

Design and typography by Jeff Berner
Diagrams and drawings by Sharon McCormack
Cover design by Irving Freeman and Jeff Berner

First Avon Printing, April, 1980

AVON TRADEMARK REG. U.S. PAT. OFF. AND IN OTHER COUNTRIES, MARCA REGISTRADA, HECHO EN U.S.A.

Printed in the U.S.A.

CONTENTS

PREFACE

When I saw my first hologram in 1971 in the Exploratorium at the Palace of Fine Arts in San Francisco, I said to my companion, "Amazing!" and walked away. That first encounter was with a still-life laser transmission hologram of a glass of red wine by Lloyd Cross. After years of color photography, multimedia work, and studies and teaching in avant-garde art history, I knew that no matter how innovative a technique may be, I want to be touched, informed, moved by the content of a given work. In the early days of conventional photography the first images were objects—still lifes—because the long exposures required such stillness. The same has been true of holography. So my response to the wineglass was minimal. I liked my illusions and hallucinations a little hotter, thanks.

Meanwhile, I was exploring the relationship between light and the resulting image, and the effects they produce on the consciousness of the viewer. I have found it exciting to root around in the development of the avant-garde arts that invaded European and American culture beginning around 1880 when, apparently unable to wait until 1900, the twentieth century was born. The last few years of the nineteenth century saw tremendous upheavals in thought and action, as the industrial revolution swept across the Western world. In the face of the dehumanizing forces of the "machine age," one of the more significant things that the pioneers of modern art did was to bring an awareness of humanity's unconscious realms to society at large. By 1905 both Einstein and Freud were thinking up a new universe, and Darwin had already caught the imaginations of scholars and journalists on both sides of the Atlantic. The entire conception mankind had of itself, time, space, the mind, and the origins of life on earth was being turned upside down.

From the time I encountered my first hologram, some years passed during which I produced a large number of still photographs and a series of multimedia shows on subjects ranging from a master mariner's bicentennial yacht race to open-heart surgery. My major attention, however, was devoted to photographic sandwiches, the combining of two images to create visions of the floating world, or dream-spaces. By 1975 I had written *The Photographic Experience,* a historical, technical, and personal exploration of the photographic act, emphasizing the use of photography as a way into the education of vision, and visual meditation beyond photography.

Yet no-matter how rewarding these explorations were, and no matter how illusionary I could make images in-camera and with lap-dissolve units in multimedia presentations, I was still confined to the flat surface of the print or the screen. In 1977, when I learned that the first school of holography in the world, founded by one of the pioneers in the field, Lloyd Cross, was just across the Golden Gate Bridge in San Francisco, I called to see what I could see.

Upon meeting Cross in the labyrinthine Multiplex studios and seeing a number of motion holograms (he invented the technique of reconstructing motion in holography), I arranged to take a beginning course. During intensive hours around the "red desert" of the isolation table, he quickly moved me beyond my initial bias toward "meaningful content" in the new medium, showing me among other things that what is perhaps more interesting than the subject matter of a given hologram is the light zones which it records and the spaces it often creates. Throughout my years of camera work I have marveled at the qualities of light I was seeing, no matter what that light was reflecting from. But in photography one is limited to the *graphic* display of light, not sculptural. After making my first image plane transmission hologram, my original interest in seeing *per se* had been expanded not just to three dimensions but to N dimensions.

During those early classes and continuing through the completion of this book, Lloyd Cross and his associates at the School of Holography—Sharon McCormack, Judy Eisen, and Michael Kan—generously shared their collective years of experience and innovation at the growing edges of this unique medium. And Rosemary Jackson, the founder and director of the world's first Museum of Holography in New York City, provided invaluable assistance in gathering information and sharing the resources she and the museum have developed from among their worldwide network of holographers. I gratefully acknowledge the kind assistance and support these holographers have given, as well as that of the contributors to the "Other Voices" section of this book.

Jeff Berner
Mill Valley, California
July 14, 1979

In an awesome little anecdote some years ago in the popular press, one of the observers at the first atomic-bomb test in the Nevada desert reported that as the fireball detonated in the distance he could clearly see the bones in his outstretched hands *with his eyes closed*. Psychedelic experimenters often tell of seeing through flesh, and scientists achieved that ability with the discovery of the X ray in 1896.

In every culture throughout recorded history the passion for seeing has been unquenchable. In the folk arts, mystic rites, fables, and sciences of people everywhere the fascination with seeing into, through, and beyond the visible realms of reflected light has kept us transfixed. For some it is the image revealed that is of prime importance, and for others, such as artists and mystics, it is the nature and qualities of light itself that not only transfix the eye and spirit, but transform them.

Illusions in art and visions in the realms of the spirit play hide-and-seek with us, and recent developments in laser and holographic science have brought us to yet another edge in the evolution of human visioning.

Trying to describe what a hologram is to someone who has never seen one is akin to describing a dream or reporting the sighting of a UFO; it is easier to say what it is *like* than what it *is*.

During experiments in sensory deprivation performed in recent years, when subjects are placed in anechoic chambers devoid of sound and light, volunteers invariably experience visual hallucinations after various periods of isolation. Everyone has a different threshold after which such visions as faces, landscapes, birds, and all manner of things appear—but they always do appear. Often they are phantasmagorical, as the subconscious contents of the mind project into space. The brain, deprived of all external stimuli except the sounds of the body which is its host, does not wait long before projecting the stuff of life into the void. The retinal circus prevails. After prolonged periods of isolation auditory hallucinations occur, such as the imaginary bird beginning to chirp, and much later subjects sometimes feel the touch of the immaterial feathered beast on their fingertips.

In ancient Egypt heirs to the throne were initiated in just such a

manner, required as they were to enter special chambers within the pyramids, to remain for many hours in order to learn both a kind of cosmic courage and to receive the images and voices of their personal spirits, as well as to make direct contact with those of the collective gods.

One need not be mystically inclined, however, to experience that wondrous zone between the real and the surreal, between matter and energy, thing and idea. As we shall see later, the confrontation of the brain/mind with the hologram provides a fascinating experience of comparison between what you see and what you are. By placing your hand into the space defined by a holographic image you may have the realization that the object reconstructed in light and the living hand are equally "real," both manifestations of light and dancing molecules. And when the viewer further understands that vision does not take place in the eye but in the brain, and that the hologram is not the screen but that it is projecting onto the eye—only the most jaded gimmick-monger will fail to experience a shock of recognition about the nature of life, the insatiable dream.

So quickly is the holographic medium evolving that the present volume would have to be loose-leaf bound in order to remain current. Although conceived more than thirty years ago, holography has been practiced for only the past seventeen years or so, and just within the last four or five years have more than a handful of serious artists been using the medium. Therefore, there are no tidy critiques to be made at this stage of its development. To do so would be a disservice to the elegantly flowing currents of the world of holography.

In the following chapters I have attempted to provide windows onto the inner and outer landscapes recently opened to us by the emergence of holographics. As with all things in this ever-accelerating world, the theories, applications, and data piles grow at enormous rates. The scientific, artistic, social, and psychological aspects of laser holography could easily fill an encyclopedia, and such a volume could be stored on a hologram about the size of this page. Therefore, my effort here is to provide an introduction to a realm of experience which itself promises to be an introduction to forms of things as yet unknown.

THE
EXPLODING

Photograph of HEMOGLOBIN MOLECULE, 1974, 360° integral (motion) hologram, directed by Cyrus Leventhal and Hart Perry from a computer image by Bornholdt, Kahn, Perry, Terutz, Christos and Tountas. Produced by Jody Burns, New York Art Alliance. Photo © 1976 Daniel E. Quat.

Today we're beginning to realize that
the new media aren't just mechanical
gimmicks for creating worlds of illusion,
but new languages with new and
unique powers of expression.

—*Marshall McLuhan*

Holography may take its place in scientific history and in art
history as a breakthrough as important as the splitting of the atom
and the invention of perspective in Renaissance painting.

Since about 1880, as the machine age roared in upon us the
intersection of technology and art has brought us many new visions.
Picasso began expressing the leap from linear space into multiple
perspectives as early as 1914. In his drawing "Study of Glasses" of
that year, he drew the same glass from a number of sides, from the
top and the bottom. In another drawing, "Still Life with Glass, Bottle
and Playing Card," he systematically destroyed central perspective.
The observer is no longer nailed to the spot as in traditional
perspective drawing, with the vanishing point out on the horizon. In a
major shift of expression, the viewer becomes one moving vanishing
point, and the other shifting infinity is found in the picture.

Photograph of HEMOGLOBIN MOLECULE, 1974, 360° integral (motion) hologram,
directed by Cyrus Leventhal and Hart Perry from a computer image by Bornholdt,
Kahn, Perry, Terutz, Christos and Tountas. Produced by Jody Burns, New York Art
Alliance. Photo © 1976 Daniel E. Quat.

At the same time that the world was literally exploding into World War I, the Dadaists were discovering themselves, and in their practice of jamming visual elements together in unaccustomed and often shocking ways, they consciously reflected the shattering of the old physical forms and traditional beliefs in the natural order. Artists and poets such as Francis Picabia (who combined painting, constructions, and theater), Kurt Schwitters (who, along with Picasso, invented collage), and Guillaume Apollinaire (whose poetry and criticism helped define the Cubist movement) dismembered and rearranged the elements of the real world into violent expressions of what was happening to the human sensibility under the crushing blows of industrialism and war. The new sense of relativism in the air was also plastered on the walls all across Europe, in art and graffiti.

When André Breton, one of the more intellectually forceful of the Dadaists, met Freud in Zurich, where most of the avant-garde of Europe had fled to avoid conscription, their conversations brought the dimensions of the subconscious and dreams into the new arts. Dadaism blended into Surrealism, combining concrete elements of the familiar world with dreams. Poets began to do automatic writing, and artists went into trances to draw images from unself-conscious reservoirs.

Meanwhile, Apollinaire had introduced the carved masks of the African jungle into salons and galleries in Europe, asking the art world to look at them not as the mere toys of childlike races, but as the living images of archetypical personalities and forces boiling within every psyche both primitive and civilized.

As the age of invention accelerated, social patterns disintegrated; as everyone found himself "in a hurry" to keep pace with the demands of applied industry, the arts found ways of expressing this new sense of space and time. Futurism, first announced in 1909 in Marinetti's "Manifesto of Futurism," reached its richest period in the years between 1910 and 1916, reflecting the sense of urgency and movement of the times. The oft-quoted phrase "a roaring automobile . . . is more beautiful than the *Victory of Samothrace*" emblemized the love-hate relationship developing at the interface of modernity and the creative mind.

The advancement of the Kodak camera into motion pictures again marked the explosion of time and space which enveloped Europe and America in a daily shift of perceptions, rhythms, and values.

Further radicalization of image-making came with the invention

of radio, adding stimuli to the imagination, while letting the mind's eye fill in the scenes. But soon enough even that infinite acoustic space was snatched back into the control of the machines with the addition of imagery to sound in the shape of television in the 1940s. Then came color television and Technicolor movies, then 3-D movies, and so on as the Pandora's box of picture-generation blew its lid, raining hardware and software down upon the cultures of industrialized and agrarian peoples alike.

It would be antiquated, linear, and misleading to suppose that any one development supersedes, strictly speaking, what has come before. Things have a way of emerging from the inventive spirits of artists and scientists in simultaneous and overlapping times. Yet a preliminary assessment may bring us to view holography as a quantum leap in image-making, a rough analog to the legendary crystal ball of seers, although here we "see the future" in the laser light behind the images it generates. As we gaze into the window of holography we get glimpses of its potential, and cannot resist wondering if this new method of mirroring the world and of creating spaces never before seen will prove as significant to human culture as the successful introduction of accurate depth representation in the early Italian Renaissance by Brunelleschi.

It is interesting to note, in our brief look at the history of the expanding and now virtually exploding image, that in the years 1425–52 the artist Ghiberti created for the Florence Baptistry *The Gates of Paradise,* showing views of Florentine buildings, and wrote of his effort:

I strove in all measure to imitate nature as far as I could . . . they are all in frames so that the eye measures them and so true that standing at a distance they appear to be in the round. They are in very low relief, and in the plane the figures which are near appear larger and those which are far off smaller, as in real nature. And I have carried through the whole work with these measurements.

Alberti, a fellow artist of Ghiberti, was apparently the first to suggest that painting is a window through which we may come to know the visible world. Leonardo, who was the first to write down the formal principles of perspective (although almost none of his writings on the subject survive, save for a few pages in his *Notebooks*), reinforced this notion by stating: ". . . perspective is nothing else than seeing a place behind a pane of glass, quite transparent, on the surface of which the objects behind the glass are drawn."

The idea that paintings and photographs are windows onto realistic or even surrealistic dimensions has been with us for a long time. Works of graphic art have been surfaces to look at, at best creating illusions of depth. The experienced artist or draftsman, through linear techniques by now well known, brings visual attention beyond the flat surface of his representational work and "into" the implied depth of a scene. However, the hologram does not merely *represent* space, it *is* spatial. It is not an illusion of geometry to look at, but something to look into.

The metaphysics of the Middle Ages held that of all natural phenomena light was the noblest, the least material, and was the closest to pure form. It not only shone upon things beautiful, it was beauty itself. Gothic cathedrals, with their thousands of pieces of stained glass, celebrated light as the earthly manifestation of the radiance of truth originated in utter perfection by the Creator.

The physics of the twentieth century has demonstrated that light behaves as both waves and particles, as articulated in quantum theory. And that the visible light with which we are most familiar is actually only a very narrow portion of the electromagnetic spectrum, which ranges from very long low-frequency radio waves, to the ultra-short high-frequency gamma rays and cosmic rays. Cosmic rays frequently zip right through the earth and keep going.

Visible light is what allows us to see the world, although we now know that such seeing is limited to a relatively narrow range in the energy field. Our eyes are finely tuned to this range, and only through specialized instrumentation can we "read" other frequencies of light such as infrared and X rays. White light contains many frequencies (colors) and intensities, and comes from many directions. It is

described as incoherent light.

Beams of incoherent light spread out after a short distance, becoming wider and less intense with increasing distance. If this were not true, starlight would wither us, not to mention the effect of the radiation of our own local star, the sun. Even if a beam of white light is filtered so that it is monochromatic it will still be incoherent, as its waves are not in phase with one another.

A beam of photons (the "light particles" of quantum theory) that have the same frequency, phase, and direction is said to be coherent light. Only such a coherent beam of light will not spread out and diffuse over short distances. Coherent light, of just one

Photograph of transmission hologram TRAIN AND BIRD, 1964, by Emmett Leith and Juris Upatnieks. Photo © 1976 Daniel E. Quat.

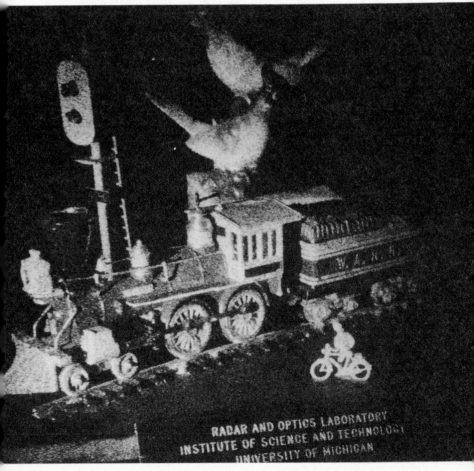

frequency and amplitude, does not occur anywhere in nature. Such pure light was first seen when a working laser was built in 1960.

LASER is an acronym for Light Amplification by Stimulated Emission of Radiation. One of the earliest models consists of a ruby crystal rod about two inches long which has been "doped" with "impurity" atoms of chromium. The ruby rod is surrounded by a photo flash tube that sends high-intensity green light into the ruby. Violent excitation of the chromium atoms occurs as the outer electrons are boosted to a higher energy level. These electrons fall back to an intermediate level and then, more slowly, to their lowest level. At this stage they emit a photon of red light: the ruby fluorescent. The photons of red light within the crystal triggers the de-excitation of a neighboring excited atom. The photon thus stimulated into radiation will be identical in both frequency and phase with the incident photon. The pair of photons which are now "in step" will then further stimulate the radiation of other excited atoms, and in a burst produce a beam of coherent light. Most of this light escapes through the sides of the crystal in random directions, but the light traveling along the axis of the crystal is reflected from semitransparent mirror coatings on each end of the ruby rod. These reflected waves reinforce one another after each round-trip reflection between the end mirrors, setting up a resonant condition in which the light builds up to an appreciable intensity. It then escapes through the more transparent mirrored end and a finely tuned beam of coherent light is emitted from that end of the laser.

The excitation of atoms and the photon stimulation mentioned above occurs in a mixture of certain gasses contained within the laser tube. Lasers employing gases such as argon/ion emit blue and green light, and those lasing in blue, green, and red have argon/krypton gases. These two lasers are extremely expensive compared with the helium/neon lasers commonly used in holography. The ratio of these gases in the laser tube is approximately 10 percent helium, 90 percent neon. The helium is essentially a catalyst facilitating the energy input into the neon, which is the active agent.

Many of today's technologies have been presaged in the speculative fiction of the past. The first suggestion of a device resembling a laser appeared in H. G. Wells's *The War of the Worlds* in 1897. In that novel describing a Martian invasion of earth, he wrote:

The invasion was backed by an immensely powerful weapon—a mysterious sword of heat. This intense heat they project in a parallel beam against any object they choose by means of a polished parabolic mirror of unknown composition, much as the parabolic mirror of a lighthouse projects a beam of light. . . . Whatever is combustible flashes into flame at its touch, lead runs like water, it softens iron, cracks and melts glass and when it falls upon water, incontinently that explodes into steam.

Before we move on to the use of coherent light in the science and art of holography, a few more details about the range and versatility of "pure" light will add perspective to the truly remarkable nature of lasers, which were actually first conceived by physicist Gordon Gould in 1957, during a restless night. It was Gould who coined the word *laser*. (When the Department of Defense learned of his ideas it immediately classified Gould's notebooks. Even he was forbidden access to them. Someone at the Department of Defense must have read H. G. Wells. This put the father of the laser out of effective action for twenty years, and only recently have the courts awarded him priority claims to the device.)

In 1958, when the principle of the laser was first announced by Charles H. Townes and his brother-in-law Arthur Schawlaw, then at Columbia University, some critics suggested that the invention was a solution for which there existed no problem. This light fantastic is currently used in such a wide variety of ways that it has been called by one observer the Scotch tape of the twenty-first century. Lasers can be built which focus such enormous energy that they can vaporize most substances in a flash. A laser beam is also capable of such delicate precision that detached retinas can be welded back into place. It can mill steel by melting the top few thousandths of an inch, transmit pictures, engrave images, and carry millions of electronic messages.

Besides the variety of uses currently found for lasers (only a few of which have been mentioned above), one of the most promising areas of application is in the field of energy generation. An ultra-powerful laser will be at the heart of what appears to be, along with solar energy, the only viable alternative to nuclear fission, and that is nuclear fusion. Fusion produces almost no radioactive wastes and has a vast potential for providing the energy requirements of spaceship Earth. In 1974, a laser system designed and build by KMS Fusion, Inc., of Ann Arbor, Michigan, produced detectable neutrons, indicating that the laser can spark some thermonuclear fusion. In California, Lawrence Livermore Laboratories' two XXIB magnetic

mirrors heated dense plasmas (electronically neutral, highly ionized gasses composed of ions, electrons and neutral particles) to 150 million degrees for very short periods. With such technologies we are on the brink of creating a veritable sun on earth. Fusion has also been achieved by electron-beam devices in Russia and in Albuquerque's Sandia Laboratories. In laser fusion, fuel pellets are impacted with a powerful laser, the contents being driven inward, creating an extremely hot, dense core where fusion occurs. In effect, such laser beams set off miniature hydrogen bombs. At Livermore's Shiva Project, scheduled for 1982, twenty individual lasers will zap plasma pellets with up to thirty trillion watts, in short bursts. This is fifty times the total electrical capacity of the entire United States power grid!

In the coming years supersensitive laser systems will be able to detect single atoms in gaseous mixtures. This will aid greatly in the early detection of the buildup of dangerous substances in industrial workers, and in the monitoring of the environment in general. Lasers will be employed in the search for that elusive subnuclear particle, the quark. Laser scalpels are currently used for cauterizing blood and lymph vessels, and neurosurgeons find that its beam not only makes precise incisions but also cuts and heals tissues almost immediately.

For a number of years a laser light show called Laserium has been showing in various cities around the United States. Billed as a "cosmic laser concert," it originated in San Francisco and is customarily projected onto a planetarium dome. Because the light emitted from lasers is coherent, each color seen is "pure" green, blue, yellow, or red. The concert consists of delightful patterns and dancing configurations, some hard-edged and others more diffuse like interstellar gasses, all accompanied by various kinds of music. Knowing that lasers are used for such awesome purposes as stimulating fusion, healing delicate organs and even single cells, guiding missiles and, alas, killing living things, it is a pleasure to see such pure, living light just romping around in the planetarium sky with stars projected across the dome of space.

Now that an acquaintance has been established with the nature of pure coherent light, and some of its applications, we are ready to explore its essential role in revolutionizing the image through the extraordinary medium of holography.

Photograph of transmission hologram PORTRAIT OF DENNIS GABOR (1971), by R. Rhinehaart, engineer. Photo © 1976 Daniel E. Quat.

The history of holography began in 1948 with the publication of a paper by Dennis Gabor of the Imperial College of Science and Technology in London. Gabor had discovered that by means of a coherent background or reference wave he could record the phase as well as the amplitude of light waves. From this record he found that he could then recreate the original light-wave pattern. His efforts were directed toward enhancing the images of the electron microscope, as he later stated:

I discovered the basic principle of wavefront reconstruction of a hologram (that is to say, from an "object" wave) in 1948, in an effort to improve the electron microscope. The principle was in hibernation until the advent of the laser, for lack of powerful sources of coherent light, and by 1962 I had booked it off as one of my many failures. Since that time, ingenious physicists and engineers have discovered a startling number of applications; they have realized almost everything except what I set out to do: see atoms! The explosive development of holography, which started in the early 1960s at the University of Michigan with the work of E. N. Leith and J. Upatnieks, was a great pleasure for me and a great surprise.

Gabor named his process from the Greek words *holo,* meaning whole, and *graph,* message. Holography means "the whole message," as a hologram contains all the information about the object it has recorded, including shape, contour, and position. If a hologram of a sculpture is made, and the hologram is cut in half, each piece still contains the full, three-dimensional image of the sculpture. Cut each of the two pieces in half again, and all four will still contain "the whole message," although each from a slightly different angle.

In 1963 Leith and Upatnieks carried Gabor's technique of reproducing great amounts of information on extremely tiny areas further along. These two electrical engineers applied the idea to light itself.

A hologram is a recording on film of two light patterns which strike the film plane from two different angles. Where the two patterns intersect there is created a new pattern which did not exist in either of the original two. This combination is called an interference pattern or wave front. A rough analogy to this interaction may be seen when two stones are dropped a few feet apart onto the still surface of a pond, both striking the water at the same moment. Upon impact circular rings radiate from each stone, and where these rings meet and overlap there occurs an interference pattern.

Something similar happens with light waves of the same frequency: Instead of striking water with two equal stones, the holographer strikes a film plate with two equal diffused laser beams. One of these coherent beams strikes the film without having picked up any information. This is the reference wave or coherent background Gabor thought of using in 1948. It is known in holography as the reference beam because it is the reference against which the other beam is compared. That other beam is aimed at the object to be recorded on the film. This object beam

picks up the information about the object and reflects the message of its shape and relative position onto the film plane. It also reflects the contrasting highlights and shadows of the object.

Because a hologram records vibrations as tiny as those of light waves, holograms must be made in vibration-free environments; that is, as vibration-free as possible in order that the film will not record the tiny vibrations of the equipment used to make it. Therefore, an isolation table is required for a "high fidelity" image. There are a number of table designs in use, but the most widely used and the least expensive to construct is the sandbox vibration isolation system invented by artist Jerry Pethick and holographer Lloyd Cross in 1968. The sand in the box adds ballast for overall stability, and also provides a convenient medium in which to stick the various optical components for manipulating the light paths in different configurations for different types of holograms. The isolation table shown here can be constructed easily and inexpensively from materials available at almost any hardware store.

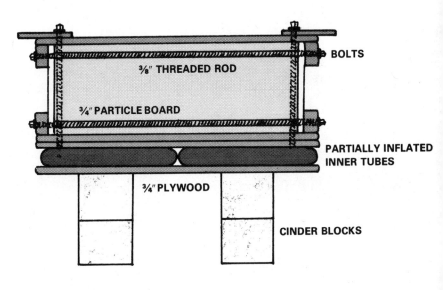

BOLTS

⅜" THREADED ROD

¾" PARTICLE BOARD

PARTIALLY INFLATED INNER TUBES

¾" PLYWOOD

CINDER BLOCKS

THE ISOLATION TABLE END VIEW

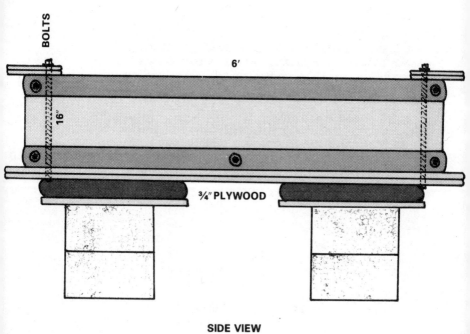

BOLTS

6'

16"

¾" PLYWOOD

SIDE VIEW

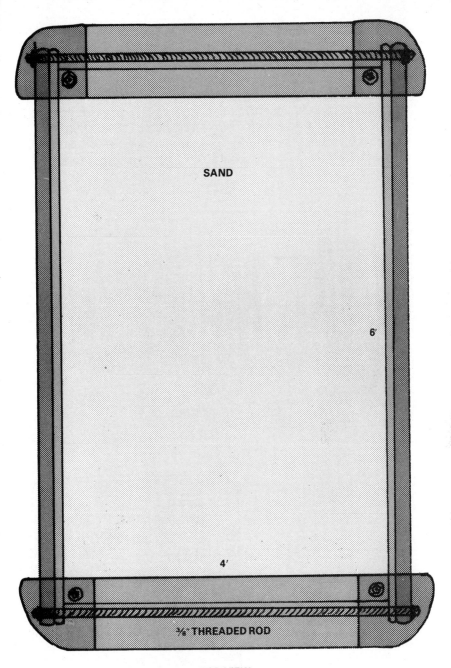

SAND

6'

4'

⅜" THREADED ROD

TOP VIEW

OPTICAL COMPONENTS FOR THE HOLOGRAPHIC ISOLATION TABLE SETUPS

Likewise, the front-surface mirrors, negative spreading lenses, the variable beam splitter(s), and any light-diffusing plastic screens may be obtained in surplus stores or hobby shops. These items should be securely mounted on aluminum or polyvinyl chloride (PVC plastic) tubing for positioning in the sand of the isolation table.

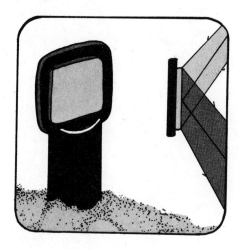

FRONT SURFACE MIRROR

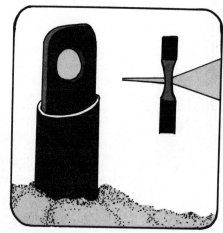

CONVEX SPREADING LENS

These components harness the pinpoint laser light and reflect it with mirrors, split it with beam splitters, spread it with lenses, and diffuse it with diffusing screens. These simple-to-construct tools create the required pathways for the laser light, and the variable beam splitter can lessen or intensify the light passing through it simply by being raised or lowered in the sand. These components are easy to assemble, and creating such a stable of components can be as individual and creative as carving and playing with one's own chess set.

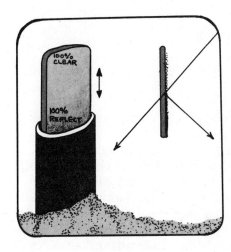

VARIABLE BEAM SPLITTER

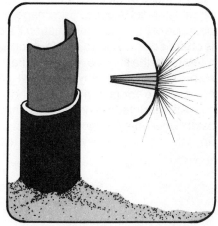

FROSTED PLASTIC DIFFUSING SCREEN

A laser is, of course, the heart of the holographic process. A neon/helium (red) laser of 15 mw amplitude may be purchased for a few hundred dollars, or one may be constructed for considerably less.

Once the isolation table has been constructed in a studio which is as free of vibration and outside noise as possible, and the sandy desert is equipped with the requisite optical components, including a stable holographic plate holder, the holographer is ready to conduct an interferometer test.

THE INTERFEROMETER TEST

An interferometer test is made to determine how stable the isolation table and its surroundings are.

When the two pinpoint reference beams are created and targeted exactly on top of one another, as shown in the setup on page 18, and spread with lenses, an interference pattern will appear on the test card. The circular, alternately light and dark fringes should be stable (see page 48). If they are wriggling it indicates that the table, some of its components (lenses, mirrors, etc.) or the surrounding room or building are being subjected to extraneous vibrations. Anything from an earthquake to a sneeze or less can disturb these fringes. If a hologram were to be made under such circumstances, the resulting image would be blurry or nonexistent because of this "extra information." A hologram of high visual fidelity is obtained only when a stable, information-free reference beam interacts at the surface of the film plane with the reflected rays of a stable object beam. Any additional information from shaking or noise will be added to the final holographic image and will ruin it.

After an interferometer pattern has been satisfactorily established, the components illustrated on pages 15 and 16 are set up in the configuration appropriate to the kind of hologram one wishes to make.

INTERFEROMETER SETUP

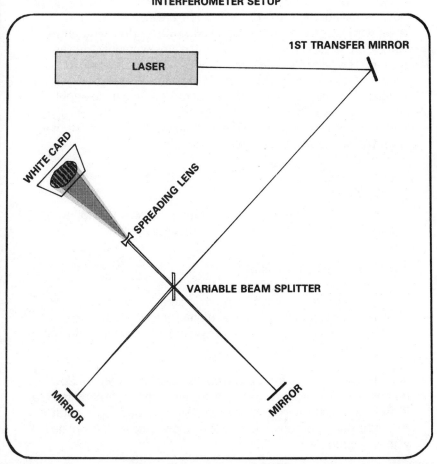

There are a number of different ways to holograph. We will focus primarily on the laser transmission hologram for the basic example of hologram construction. (Holography is rightly thought of as construction because to expose a holographic plate or film is to construct a certain shape or contour of a light sculpture, an interference pattern of realigned-by-light silver halide crystals, forming a kind of infinitely subtle diffraction grating. When this gossamer construction is developed and then illuminated by a beam striking it at the same angle that the original reference beam struck it upon exposure, the fully shaped image of the original object is *reconstructed*.)

The laser transmission hologram is the highest fidelity form of holography, as it is reconstructed with a laser. The white-light transmission hologram, reconstructed by an ordinary uncoated light bulb, is considerably less brilliant. There are also white-light reflection holograms (see set up on page 30) and the intriguing white-light reflection dichromates which are commonly seen as jewelry (see page 51). The depth of field, or sculptural field, of dichromates is quite shallow, and as the angle of view changes the image becomes distorted. But the dichromates are quite bright because, unlike other kinds of holograms using silver halide crystals that partially absorb light, the dichromate chemistry contains many layers of hardened, highly reflective gelatin.

In order to construct the configurations shown in the following illustrations, the isolation table should have available:

2 variable beam splitters
3 60x convex spreading lenses
5 mirrors, front surfaced, approximately 5 × 5 inches
2 plate holders for 4 × 5-inch plates, or for 8 × 10 inches
Plus one ruby red laser of approximately 15 mw (helium-neon type)

The two plate holders can be constructed like small window frames, except that they are open at the top to facilitate sliding plates in and out. The slot into which the plate fits must be snug enough to hold it very still, yet sufficiently wide to allow removal of the plate without a struggle.

THE TRANSMISSION HOLOGRAM

As mentioned above, the classic laser transmission hologram is the highest-quality and most deeply dimensional hologram currently possible. Setups are shown here for a single object beam and for a double object beam staging. A single object beam is often sufficient, but just as in conventional photographic or theatrical lighting the more spotlights or floodlights there are illuminating the object from different angles, the more depth is achieved, so in holography the addition of another beam will emphasize the dramatic qualities of the subject. In order to add a second object beam, simply introduce another beam splitter into the unspread path of the first object beam (see page 28).

In the transmission hologram, both the reference beam and the object beam(s) fall onto the same side, the emulsion side, of the plate or film. For this type of hologram, antihalation film plates are used; they are backed on one side to prevent light from bouncing back through the plate.

When lighting the object of the hologram, a diffusing screen (such as that shown on page 16) may be placed between the diffusing lens and the object in order to soften the light or eliminate any highlights considered too hot.

When you have selected an object (or objects) that you wish to record holographically, place it on the isolation table near the empty film plate holder. Look through the holder as you would peer through a window, positioning the object exactly as you want to see it in the finished hologram. Move your head around to get views from every possible angle.

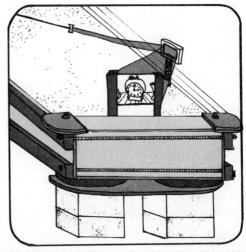

THE HOLOGRAM AS A WINDOW

Now place a white card the same size as the film plate you are going to use (customarily 4 × 5-inch or 8 × 10-inch) into the holder, white side toward the object. Turn on the laser and bounce the beam onto the playing field with the first corner mirror.

Near the middle of the isolation table is the beam splitter. Aim the laser beam through the variably reflective beam splitter (see page 24), forming two beams. One beam—the object beam—goes straight through the splitter. Bounce it off a second mirror diagonally across from the first mirror. Then put a spreading lens between the second mirror and the object, providing a bath of light for the object.

The other beam—the reference beam—is bounced toward the white card in the holder by another mirror; it is also spread out by a little lens, providing a bath of light for the white card. This light should cover the card as evenly as possible.

Measure the distance the object beam travels from the beam splitter to the first mirror, through the spreader lens to the object, and onward to the film plane. Then measure the distance the reference beam travels from the beam splitter to the other mirror and onward through its spreader lens onto the white card. These two distances must be as close to equal as possible. (If two object beams are used, as seen in illustration on page 28, each object beam must be measured from the second beam splitter, to its mirror, through its spreading lens, to the object, and on to the middle of the plate holder. The beams must be of equal length. (The length of each object beam must also equal that of the path followed by the reference beam.)

Once the object is illuminated as you like it and the white card is evenly lit, check the relative brightness of the reference beam and the object beam. In order to achieve good contrast in the final hologram, a ratio of about three to one is required, the reference beam being the brighter. You can check the ratio by interposing a few fingers between the spreading lens and the white card on the reference-beam path. The shadow of your hand should be approximately one-third darker than the light on the background card.

Now leave the room in order to allow the object you will holograph, the mirrors, the lenses, the plate holder, and the isolation table itself to settle. Even the air in the room must come to rest. Such stillness is essential to record a sharp image. As mentioned earlier, holography is an activity involving the vibrations of light and the patterns created by the interaction of coherent light beams. No other waves of information are wanted in the hologram. Depending on the design and construction of the isolation table, the building it is in, and its environment, about fifteen minutes should be sufficient for all the elements to settle.

BASIC TRANSMISSION HOLOGRAM SETUP (SINGLE-OBJECT BEAM)

After the whole system has settled, return to the isolation-table room and check the ratio of the reference beam to the object beam once again. Is it still three to one? Is the object still illuminated as you wish? Are the lenses and mirrors in the same positions as when you left them? The settling you allowed by your absence from the room may have shifted the various elements in the system. Be sure things are set up correctly. Minor corrections can be made gently but make sure you do not lean on the edges of the isolation table—something which is done unconsciously by almost every beginning holographer. When you are sure that everything is in position, shut off the laser by remote switch or by shuttering.

In complete darkness (except for a green safe-light), remove the holographic plate from its protective envelope. Remove the white card you have been using for the light target and substitute the photosensitive plate, emulsion side toward the object. (Holographic film is a high-contrast, fine-grain black-and-white emulsion customarily carried on a glass plate. A commonly used product is Kodak Pan X, which resolves 90 lines per mm. Another satisfactory film for holographics is AGFA Gevaert 8E75, which resolves approximately 3,000 lines per mm. Different films are prepared for sensitivity to different wavelengths. The AGFA Gevaert 8E75 is sensitive to the red regions of the spectrum and is therefore used with the red ruby lasers commonly found in holography outside of the high-technology industrial laboratories. Kodak 645F is several times slower and "reads" the whole spectrum of visible light. Kodak 120 plate or S0173 is similar to the AGFA 8E75, but is not as sensitive.)

Now leave the room once again. Give the system, including the newly filled plate holder, another five to ten minutes for settling. Patience is a virtue, and holography imposes a kind of contemplation, if not meditation, on its practitioners.

Now you are ready to expose the plate. From a remote switch, turn on the laser for the amount of time determined by your light meter. You are exposing the plate to that dance of light discussed earlier, the dance between the two partners known as the reference beam and the object beam.

What is burned into the film emulsion is the contours of interference patterns, the wave fronts, set up by the interweaving of the rays of the object beam and the reference beam. The object beam bounces off the object, bathing the film plate with needles of light from every angle within view of the plate. The reference beam, carrying no information about the object being holographed, also spreads its light on the film plate.

The combined light creates in the silver halide crystals of the film emulsion a microscopic diffraction grid of contours that echo and imitate exactly the surfaces present in solid form a few inches away. The hologram may be thought of as a sheet of uniquely arranged diffraction lenses which, when reilluminated by the laser from the same angle at which reference beam originally struck it, plays back the spitting image of what was near it during the time of exposure. The expression "spitting image" was originally "spirit and image" some centuries ago, and holography is the best technique we have for repeatedly reuniting the two.

After the exposure is made (depending upon variables almost as easily determined as in conventional photography), turn off or shutter the laser, remove the film, and place it into its protective envelope. Then develop it.

For our example, assume that the object you have holographed is of average reflective intensity, and that the laser employed is the helium/neon type of 15 mw. If the plate used is an 8 × 10-inch Kodak S0173, the development procedure might go something like this:

Develop the plate for about two minutes in Kodak D 19 high-resolution developer. Length of development depends upon the original brightness of the object, length of exposure (for our example, about three seconds), and temperature of the developer. Stop the plate for about thirty seconds. Then fix the plate for three to five minutes. After that, wash for about ten minutes in Photoflo. Squeegee and dry thoroughly.

Now you are ready to reconstruct and view your holographic plate. In the case of the laser transmission hologram, the most dependable method is simply to replace the plate in its original plate holder and turn on the laser, allowing the reference beam to strike the surface from exactly the same angle as it did during exposure. Block the object beam with a card.

Unless you have seen a laser transmission hologram you can not imagine the impression this highest-fidelity method of holographics provides the gazing eye.

If you discover upon reconstructing the hologram that the image is not as bright as you want it to be, return to the darkroom and bleach the plate in a solution such as cupric bromide. However, such brightening involves a compromise, as the brighter the image after bleaching, the muzzier the final image will become. In any case, darkroom techniques for holography are essentially the same as those for conventional photography. (Highly detailed accounts of current holographic procedures may be found through the

Resources section at the back of this book.)

Holograms are frequently described as being exactly like the object being recorded. In fact, a classic laser transmission hologram is more luminous by far than any object seen in natural light. Laser illumination is the essence of shimmering, rich light. A hologram of this type is "exactly" like the object recorded not in its general appearance, but in its topology, or contours.

A dazzling example of this became evident while making the hologram of the Florentine gilt angel appearing on page 50 seen opposite a beaming helium/neon 15-mw laser. After exposing and developing the 8 × 10-inch plate, the three of us who created the image and lighting reconstructed the hologram with the reference beam of the laser, viewing it in its original plate holder on the isolation table. The angel sculpture itself, which had been left untouched in its original position, was bathed again with the object beam. Viewing the reconstructed hologram and seeing the sculptural angel itself through the window of the holographic plate revealed an interference pattern across the contoured surfaces as they interacted once again. This was a very rare occurrence, indicating that we had replaced the plate into its holder in exactly the position it had been in at the time of exposure. The holder evidently had not shifted one bit. Neither had the angel. The light "mold" of the hologram was in the identical relationship to the angel in which it had been upon its creation. The contours of the reconstructed light of the hologram and the contours of light reflecting from the actual object surfaces were snug as could be.

With both the hologram and the object in their original places, look at the hologram and reach over the plate and remove the object. It will appear to still be there! Or by alternately blocking first the object beam and then the reference beam, the hologram and the object may be compared.

A property making a hologram unique in human experience: If you take a hologram and cut it into pieces, or even smash it, every piece will still contain the whole picture, although very much smaller. Image clones!

BASIC TRANSMISSION HOLOGRAM SETUP (DOUBLE OBJECT BEAM)

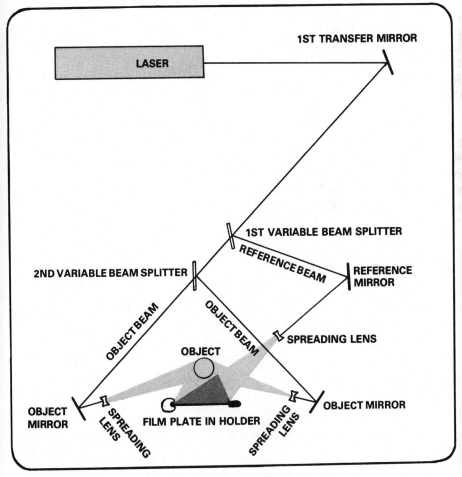

28

THE REFLECTION HOLOGRAM

This is the other basic kind of hologram. It is displayed, or
reconstructed, not with a laser but with ordinary, incoherent, white
light. A typical isolation table set up for making a reflection hologram
appears opposite. Notice that in this kind of image-making laser
light strikes the film plate on both sides, so naturally, un-backed
plates are used in this method. Reflection holograms are more
conveniently displayed than transmission types, as any good light
from an ordinary light-bulb (uncoated), a spotlight, a projector light,
or the sun will reconstruct a good image. Flourescent lighting,
however, will not.

Reflection holography was invented by the Russian scientist
Y. N. Denisyuk in 1961.

REFLECTION (WHITE-LIGHT) HOLOGRAM SETUP

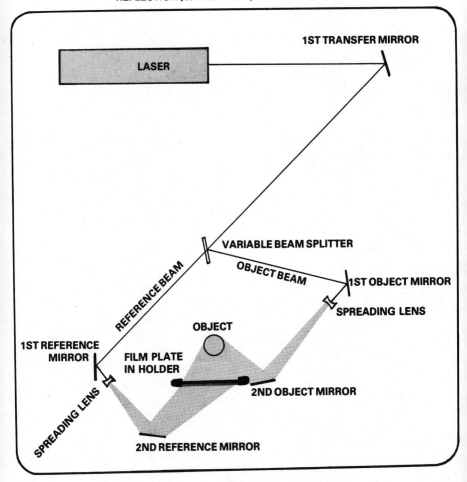

MAKING DICHROMATE REFLECTION HOLOGRAMS

As mentioned earlier, dichromates are the brightest reflection holograms because they use no silver in their emulsions, but rather contain many layers of hardened gelatin crystals which react to the laser light. Dichromates are highly reflective, but depth is minimal and shifting angles will often distort the image. The pendants seen on page 51 are dichromates. A dichromate solution can be painted on any nonporous surface, giving incredible range to the image-making imagination.

REFLECTION (WHITE-LIGHT) HOLOGRAM SET-UP

TOP VIEW

L↑ R↑

**NORMAL IMAGE
ORTHOSCOPIC
NORMAL DIMENSIONALITY**

TOP VIEW

R↓ L↓

**PROJECTED IMAGE
PSEUDOSCOPIC
"INSIDE OUT"**

The dichromate method of creating holographic images was developed by Shankoff and Pennington in 1967. The emulsion must be preserved in a vacuum because no fixative has been invented for it yet. Dichromates must be exposed in the configuration seen in the setup below, using an argon laser rather than the helium/neon laser used in all the other setups. Dichromate images are blue-green or gold due to the color of the argon laser. Another unique aspect of this type of hologram is that the image is exactly the size of the original object and cannot be reduced or enlarged.

REFLECTION HOLOGRAM (DICHROMATE) SET UP FOR WHITE-LIGHT VIEWING

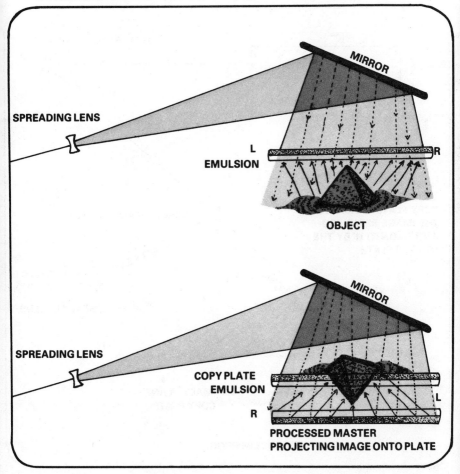

USING A MASTER TRANSMISSION HOLOGRAM TO MAKE COPIES OF REFLECTION HOLOGRAMS

Because only the coherent light of a laser will burn an image onto holographic film, the only way copies of a holographic image can be made is by using a hologram, which is itself a laser displayed plate, as a master for making white-light displayed copies. Notice that in the setup below, the master transmission hologram is itself the "object" of the hologram to be made. The expression "image plane" refers to the fact that the three-dimensional image will appear to project about halfway in front and about halfway behind the plane of the glass plate.

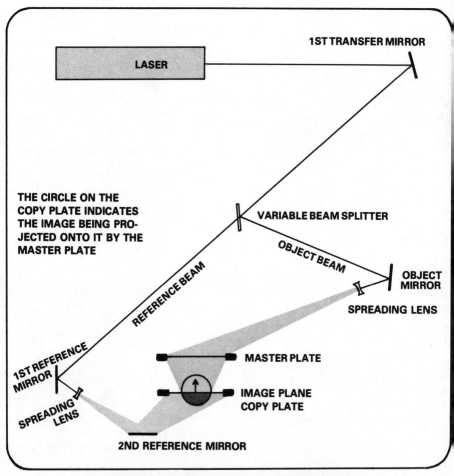

**REFLECTION (WHITE-LIGHT) HOLOGRAM SETUP,
USING A MASTER TRANSMISSION HOLOGRAM TO MAKE COPIES**

INTEGRAL (MOTION) HOLOGRAMS

Holographic movies (also called "Holodeons" or Multiplex holograms) have attracted a great deal of attention wherever they have been shown, and are the most popular form of holography in the commercial field. In 1972 Lloyd Cross merged the motion picture with holographic recording techniques, creating white-light motion holograms. "Integrals," as they are often called, do not represent depth, that exciting sculptural dimension which makes holography so captivating to the senses and imagination. But integrals do "capture" time, as do conventional movies.

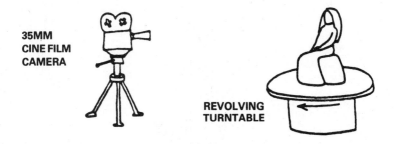

35MM CINE FILM CAMERA

REVOLVING TURNTABLE

To make such a holographic movie, a 35-mm motion-picture study is made of a subject which is rotating on a platform, so that each frame of film is just one-third of a degree apart from the previous one. For a 360-degree display 1,080 frames are shot. Fewer frames are required, of course, for recording just "one side" of the subject—540 frames for a 180-degree display. All this is done with conventional film and lights. The processed film is then put into a special holographic camera and each frame of the film is holographically projected onto a narrow vertical section of 9½-inch holographic film (not a plate). This process is repeated until 2,160 holograms are recorded onto a piece of film which is later joined at the ends to form a circle. Mounted on a frame and illuminated from below the floor of the display with an ordinary, uncoated white light bulb, motion is re-created either by the movement of the spectator or the rotation of a motorized display. Naturally, a 180-degree display will remain stationary, and the viewer will walk past the image. A 360-degree display is usually shown on a moving "lazy susan" type of platform.

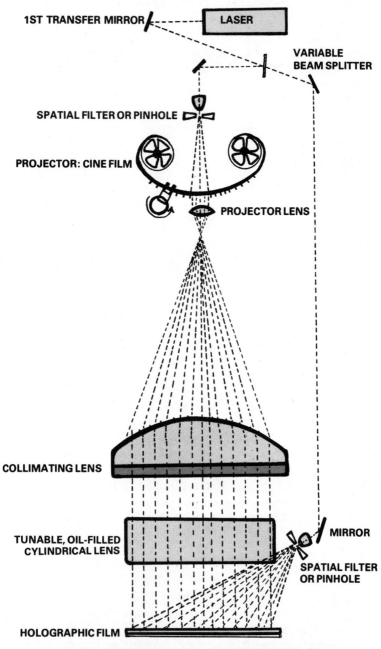

1ST TRANSFER MIRROR

LASER

VARIABLE BEAM SPLITTER

SPATIAL FILTER OR PINHOLE

PROJECTOR: CINE FILM

PROJECTOR LENS

COLLIMATING LENS

TUNABLE, OIL-FILLED CYLINDRICAL LENS

MIRROR

SPATIAL FILTER OR PINHOLE

HOLOGRAPHIC FILM

MARK V INTEGRAL HOLOGRAPHIC PRINTER (SIDE VIEW)

When you are doing the original filming for an integral hologram, diffuse the lighting in order to minimize sharp moving shadows, and shoot for lower than normal contrast. Then print the positive for black blacks. The subject should be well centered in the frame, and the background should be blacked out. Adjust the frame rate and platform rotation to obtain 1,080 frames for a single 360-degree rotation of the subject. Film used is black-and-white Kodak Plus-X negative.

Using different techniques, motion can be slowed down or speeded up.

MAKING COPIES OF INTEGRAL HOLOGRAMS

Lloyd Cross has also invented a printer for making duplicates of integral (motion) holograms. The illustration opposite shows the workings of his Mark V printer. Even this piece of sophisticated machinery can be made at reasonable cost from materials obtainable at almost any hardware or surplus store. (See Resources section for further information.)

The holographic artist Harriet Casdin-Silver has said:

Holography is a medium of fantasy, of mystery. The image is there—but reach for it—nothing. At the moment, however, there is great fascination with the technological means. How is it done? How can the image be there and not be there? Eventually the spectator will forget the tools and the technique and allow the experience to happen.

SOME SOCIAL DIMENSIONS

When Artoo Detoo delivers his messages from Princess Leia it is in the form of a foot-high hologram *like* image of her projected into the room, moving and talking. In another special effect in that now-legendary *Star Wars* film, Artoo plays a chesslike game with a wookie, using "holographic" pieces, which are actually conventional double exposures.

Although these images appear in a motion picture from A.D. 1977, and are not actually holograms, the many millions of viewers who see the film will forever think of holography as originating in a galaxy of many light-years' distance.

Spectators viewing a 360° integral (motion) hologram at the Museum of Holography installation at the Crafts Fair, NYC, 1975. Photo © 1975 Steven L. Borns.

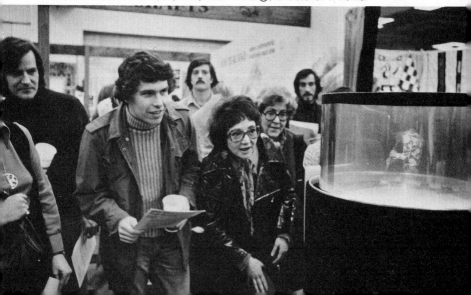

Two earth-years earlier, a film set in the twenty-third century, *Logan's Run,* included actual integral holograms of the actor Michael York being questioned as his image is fragmented into six projections. In the story, a computer interrogates each of his six "personalities."

These speculative futures are appealing, just as all imaginative predictions have a magic all their own. But there is ample material on the current and real applications of the holographic arts and sciences to keep any observer busy just gathering data. A collector of holographic lore and of "firsts" can easily feel he or she is surfing on the leading edge of a giant wave with a long way to go before it breaks. Here are a few of the many ways in which holography is impacting on the social dimensions of our time:

Jewelry probably accounts for the largest number of holographic images currently in circulation. They are reflection holograms made by the dichromate method, and almost always in the form of silver-dollar-size pendants. The subject matter is usually kitsch, although a few rise above the level of signs of the zodiac or watch parts (see page 51).

Holography reduced to a promotional toy is being offered by a company in Pennsylvania that specializes in trade-show and showroom "traffic builders." It sells a "Lucky Keyhole," which incorporates a half-inch-by-one-inch transmission hologram in a four-by-seven-inch invitation card. The card is mailed to prospects who are invited to the show booth to play "Lucky Keyholes" for a gift.

Holography for amusement is obviously a wide-open field, and early applications have been seen in a haunted house at an Ocean City, Maryland, amusement pier, where holographic skulls float near the ceiling of a seance room. At the Wax Museum at Fisherman's Wharf in San Francisco, a witch holding a crystal ball was projected toward the viewers, and within the ball shimmered a transmission image of the devil. Lighting problems from the surrounding area caused that project to be abandoned after a few weeks, at least according to the official explanation. It is clear that one of the biggest commercial uses of holography has been to give people the creeps. Who knows what jealousies are being aroused in the spirit world of actual Doppelgängers!

It is of some concern to serious holographers that the medium is reaching the lay public mostly in the form of point-of-sale advertising and sensationalized entertainments such as those just mentioned. The holographic medium is utterly fascinating no matter what the subject. People are sure to stop and stare.

Three national advertisers, Proctor and Gamble, the McDonald's Corporation, and the R. J. Reynolds Tobacco Company, have sponsored tests to evaluate point-of-purchase effectiveness of the techniques available to root potential customers to the spot. Throughout 1977 a display containing two integral (motion) holograms of a man smoking a Salem cigarette was on view first at New York's Grand Central Station and later at Penn Station. One might hope that passers-by will want to purchase the hologram rather than the cigarette!

As a tool of commercial hypnosis holographics run the risk of being introduced to society merely as another gimmick serving the provisional interests of Mammon. The day could come when the transcontinental highway system is littered with throw-away "Lucky Keyholes" and Cracker Jack prizes. As Cocteau once pointed out, a miracle which endures ceases to be considered miraculous. Before we are inundated with an overcommercialized, overexposed product, it may be of some importance to the growing holographic community to reach beyond McLuhan's otherwise accurate edict that the medium is the message, and pay considerable attention to the content and intrinsic messages actually being projected into the world. The medium is far too valuable to become merely another sensational gimmick from the toy chests of corporate America. One observer, an affluent photographer who had just seen his first hologram, bubbled, "Hey, I'd love to project a Porsche around my pickup truck! I could project a swimming pool in my back yard!"

Fortunately, holography has valuable uses in a far-reaching range of social environments, not the least of which is the medical field. Ophthalmologists use it to determine the actual shape of an eye, later comparing its morphology with its pretreatment state through interferometry. Holography promises to help diagnosticians and patients avoid the well-known dangers of X-ray scanning, while still allowing deep-in views of the human organism, with the added dimension of depth. In this technique, called acoustical holography, a subject with a broken arm can insert it into a sleeve and place the arm in a tank of water. Ultrasonic waves are passed harmlessly through the injured limb, and the waves are recorded on film outside the tank. The result is a record of the fractures, the densities of various tissues, such as muscles and arteries, all in three dimensions. Sculptural records of any internal organs are easily made with this technique.

Pal Greguss, editor of a large volume on the emerging field of bioholography, *Holography in Medicine,* is quoted in *Brain/Mind*

Bulletin as saying that life is based on order and pattern, "which conforms well with the fundamental pillar of holography, namely, coherence and interference. This idea of order and pattern . . . can be expanded further in the dimensions of quantum mechanics and quantum chemistry." Based on the holographic model, the Hungarian researcher and his associates are studying the phenomenon of pain. "According to our model, an organism is living and stays alive as long as it can handle—process—all the information patterns it receives." If the living organism does not provide the required coherency to process such information, due to a weakened neural activity, it will experience pain. "Pain," says Greguss, "is a need for coherency, and it falls in the same category as hunger or sexual drive."

Holography's best-known application in industry is through techniques of interferometry, which permit the study of stress on a solid object. By making a hologram before and after applying stress to the object, and then viewing both holograms together; or by making a "before" hologram and viewing it together with the object afterward, the slightest alterations of surface shape can be observed, as an interference pattern or moiré effect will occur in any nonconforming area.

Holography is just beginning to have an impact upon the world of information storage. Coupled with computers for rapid scanning and retrieval, a hologram can store far more data than either tape or microfilm. In fact, the theoretical storage capacity of a single square millimeter of hologram is ten million bits of information! A curator may record large numbers of artifacts or priceless jewels on a small holographic plate. Librarians can store vast amounts of print materials in the same manner, and the general public may one day be liberated from the necessity of traveling to libraries. Instead, an individual may have a vast storehouse of literature tucked away in a folder the size of an issue of a news magazine. Motion pictures could also be stored in a manner similar to today's integral holograms. And advances in information condensation, coupled with the miniaturization of storage and retrieval techniques coming out of the holographic field, may lead to a holographic equivalent to today's computer time-sharing systems. Some radical education theorists envision the eventual elimination of physical schools and campuses through such systems.

Holographic conferences to be held in London and New York City are on the drawing boards. As holography implies the lessening of the material density of objects, it also suggests that people may

one day be able to forget about moving their bodies and baggage through the skies on hazardous routes across the world in order to be in the presence of others.

Holography may affect our social experience as profoundly as radio and television have changed the fields of communication and entertainment. In medicine we have already benefited greatly, and tomorrow's applications are being dreamed up by filmmakers, physicists, psychologists, artists and, as we have seen, entrepreneurs. In an interview a few years before his death, the inventor of the television tube, Philo T. Farnsworth, was asked what he thought of the way in which his invention had been used in the decades since he conceived it. He said that, frankly, he was quite disappointed, and almost never watched the tube.

What makes practicing holographers excited about their medium is that unlike television, unlike film, unlike print, the directions of holography are so varied, and the social, physical, and even metaphysical implications are so multidimensional, that holography is unlikely to be painted into a corner as most specialist fields are by the necessities inherent in either their mechanics or their economics. As Lloyd Cross pointed out in a recent interview (see page 70), holography "is not a field in the common sense of the term, as compared with its nearest comparison which is photography. It has not just one more dimension . . . but it has . . . N-dimensions."

He who does not imagine in stronger and better lineaments, and in stronger and better light than his perishing and mortal eye can see, does not imagine at all.

—*William Blake*

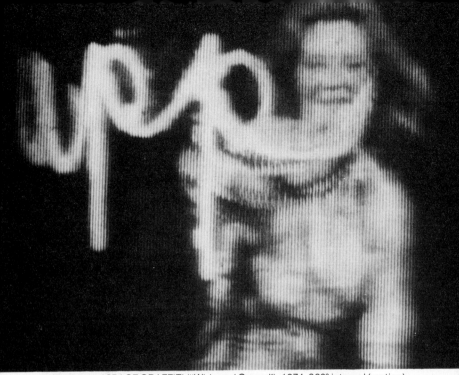

Photograph of SPACE GRAFFITI ("Whipped Cream"), 1974, 360° integral (motion) hologram by Anait. Photo © 1976 Anait Artunoff Stephens.

HOLOGRAPHY

On the evening of December 8, 1976, the world's first Museum of Holography opened in a handsome old cast-iron building in the SoHo district of New York City. More than six hundred guests were treated to seventy pieces of holographic art by artists from the United States and several other countries including France, Sweden, and Canada. During the evening, then-mayor Abraham Beame, who inaugurated the museum, was presented with a hologram of three apples by California holographer Randy James, a sight-gag on New York's well-known image as "the Big Apple." The inaugural show,

aptly titled "Through the Looking Glass," was heralded in the press, including the *New York Times,* which said, "Unlike most museums, which are repositories of the past, the Museum of Holography is devoted to presenting visions of the future." But it was not only the future that was on display that night. In a special section of integral holograms titled "The Hall of Fame," motion images of artist Andy Warhol and other luminaries attracted gongoozlers like moths to flames. New York *Daily News* columnist Pete Hamill was on display appearing to type endlessly, while network broadcaster Tom Brokaw was seen doing a "live" newscast on the city streets. A few feet away, in another integral display, producer Joseph Papp leafed through his favorite Shakespearean play, and another holographic movie featured dancers from the New York City Ballet gracefully dipping and swirling as the holograms revolved on their illuminated turntables (see page 37). Big Bird of "Sesame Street" fame was also represented, fluffing his feathers atop his famous garbage can. In one of the more compelling images, holographer Anait was seen floating in a clear plexiglass "booth," smiling, tossing her hair, and writing "whipped cream" seemingly in the air—a unique self-portrait of the artist who has dubbed these holographic movies "Holodeons" (see page 34).

Since the inaugural show at the Museum of Holography, more than sixty thousand people have passed through the museum.

A few months later, Dr. Dennis Gabor came to visit the museum. The then seventy-seven-year-old physicist* expressed his delight at seeing the artistic manifestation of his invention of thirty years before. He also saw the holographic portrait of himself made by the McDonnell Douglas Corporation in 1971 (see page 00), which commemorated his receipt of the Nobel Prize for his discovery.

Since the "Through the Looking Glass" exhibition went on tour to various galleries and museums in the United States and Canada, many more thousands of people have lined up to see the artistic expressions of the medium. The Walnut Street Theatre in Philadelphia has shown it, and in the first major exhibition of holography in Canada, a condensed version of "Through the Looking Glass," drew enthusiastic crowds. In early 1978 at the Atlanta College of Art Gallery in Georgia, the three most popular images were all integrams, which will one day be considered the "silent movies" of holography. One of these was Jody Burns's "Simon with a Camera," in which a tousle-haired young man moves and snaps visitors' pictures as they walk by. One of the most

*Dr. Gabor died in 1979.

inventive integral holograms yet seen, Dan Schweitzer's "Night at the Movies," offers the viewer a strange and humorous experience. The viewer first sees a crowd in a theater watching a film. Then, as he passes by, the actor on the movie screen reaches out to grab a member of the movie audience! And the third "Holodeon," which visitors to the gallery in Atlanta responded to as well, was the ubiquitous 1974 "Kiss II," created by the inventor of the technique, Lloyd Cross. It is probably the best-known fine-art hologram, and is becoming the Mona Lisa of the medium.

When the North Carolina Museum of Art at Raleigh opened the show, also in early 1978, it achieved a first-day attendance record when 2,136 people saw it. The previous attendance record had been set a month earlier when more than 800 turned out, interestingly enough, for a show of American realists. In fact, "Through the Looking Glass" broke the record in the first fifteen minutes, when 1,000 people passed through the doors.

Just six months previously, across the Atlantic at the Royal Academy of Art in London, an average of 3,000 people per day queued up for hours in order to cram into a single gallery room to wave their hands in wonderment through a holographic stream of water pouring forth out of a holographic faucet, and to try to pick up a holographic telephone. By the end of the exhibition, organized by Holoco, a group based at Shepperton, England, 96,000 people had "wet" their hands in a stream of light.

Fine-art holography evokes enthusiastic responses from throngs of viewers wherever it appears, in such places as the International Center for Photography in New York City, the House of Culture in Stockholm, the Ybor Square Gallery in Tampa, Florida, the Buffalo Museum of Science, the Space Transit Planetarium at the Museum of Science in Miami . . . the list is growing. Attendance figures excite holographic artists and curators, and, increasingly, collectors. But the question also arises: What is being seen? Are the avid crowds the result of something more than the fact that, as Francis Bacon wrote in the seventeenth century, ". . . the deceiving of the senses is one of the pleasures of the senses"? Susan Sontag, whose critique *On Photography* stirred that medium to controversy, considers us to be "a nation of image junkies."

The visual encounter has had enormous appeal since the dawn of vision. Image "addiction," of course, probably began when the first hominid saw the moon for the first time in dimmest prehistory. The evolution of our visual apparatus is extremely ancient in comparison with the "thinking," rational functions of the mind/brain,

which subsequently gave us, among other things, the ability to "see ourselves see" and to define our own behavior as hypnotic or addictive. Hopefully, the love of seeing something new, or seeing something old in a new light, will always be ours. Even if our culture may stand guilty as charged of focusing more on image than on substance, there are a number of qualities behind the gossamer veil of the holographic image that are deeper than the image itself, qualities beyond the appearance of things through which the hand may pass.

Perhaps the foremost aspect of the medium that keeps fine-art holographers and their audiences fascinated is the sense of space and spatial organization which it gives us. We are speaking here primarily of the stationary laser transmission hologram, which has exceptional depth because it is completely imitative of the object it echoes.

To illustrate the unique spatial characteristics of holography we can briefly indulge in a comparison with photography. Such comparisons are generally best avoided in order to minimize the already burgeoning confusion in the layman's mind about the new medium. But the dramatic contrast between the two is highly indicative of the fascinating, virtually hypnogogic power of the hologram.

In conventional photography even a moderately competent photographer can make an interesting image simply by framing his or her work in a dramatic manner. The proscenium arch of the rectangle can be used to arrange the light and dark masses and important points of attention across the two-dimensional surface in clusters and relationships of graphic tension and rhythms, much in the manner of any graphic layout and design. By taking advantage of the borders of a photograph, or for that matter, of a painting on its canvas, "artistic" composition can be achieved and fixed for all time. A certain distortion can occur, of course, if the flat plane is viewed from an extreme angle, but this would be a rare and mostly unproductive shift in "perspective." In any case, it would provide absolutely no parallax, as all perspective in a photograph is merely implied. The composition remains static.

Not so with the hologram. Because a hologram is a window through which a viewer looks (see illustration, page 20), and that view opens into a scene, it is not something to be merely looked at, as mentioned earlier. And in the case of the integral (motion) hologram, although it is not truly spatially dimensional, it may be a 360-degree display, such as a goldfish bowl. In either mode, the borders of the

hologram are forever shifting as the display or the viewer moves. As we have seen, in a photograph or painting, composition derives from the graphic elements and their relationships to the corners and borders of the plane. In the hologram, composition derives primarily from the internal spatial relationships of the objects within the frame, and their relationships to the viewer's shifting position. It is an utterly dynamic system (although current technology limits vertical parallax to some degree). Composition, therefore, becomes a mercurial dance of relationships of forms interacting with one another and with the viewer. This will become more evident as the size of holographic displays increase to accommodate larger life-size proportions.

Some holographers introduce a frame into the landscape of a scene on the isolation table, just as they have introduced magnifying glasses and other frames of reference through which the viewer may peer, providing windows onto windows. One may imagine a hologram that would include first, closest to the viewer, a wooden picture frame, through which one could see a large magnifying glass, through which at just the right angle could be seen a prism, behind all of which a large mirror would provide the background as it reflects the visual sequence from an opposite horizon.

Holography provides a striking metaphor for our twentieth-century, post-technological recognition that "reality" itself, or certainly the way in which we apprehend it, has slipped out of the classical proscenium arch, out of the tidy categorical thought patterns established in the Western world by Aristotle, Newton, and most other philosopher-kings who preceded Einstein. It was Einstein who introduced us to the relativity of all things and demonstrated this fact by modern, high-energy physics. This latter discipline has not completely discarded ideas of matter and of basic particles, but it has found that even the most elusive particles are themselves interactions and "events" rather than things. The interference patterns that create a holographic recording may be a superb example of the interference-pattern nature of all things, actions, and even thoughts in the manifest universe. Not a small claim, but one we will examine further in the following chapter.

Another quality of the hologram which keeps viewers involved in these magic windows is the luminosity of the scenes revealed. In the initial excitement surrounding the medium the most common claim made was that a holographic image looks exactly like the object recorded. Besides the fact that true color reproduction has not been achieved to date, a holographic reconstruction is far more

radiant, luminous, and buoyant than the more physical, concrete object of which it is an exact sculptural imitation. Only in this sculptural sense is a hologram exactly like its subject. This sculptural exactitude, added to the luminosity of the view, plus the purity of light reconstructed within the visual cortex, is apparently sufficiently powerful to turn image-overloaded color TV and movie viewers, artists and art lovers into true gongoozlers upon seeing a hologram. A gongoozler is anyone who stares for a prolonged period of time at something highly unusual.

Up to this point we have discussed only representational mirages, subject matter recorded in holograms of familiar context. Yet a number of holographic artists create light sculptures much as the abstract-expressionist and "action painters" of the decades following World War II did. Such holographers, notably Anait, whose amusing "Space Graffiti" is shown in the photograph on page 42, and Harriet Casdin-Silver, whose "Sphere" is shown in its display mount in the photograph opposite, have been generating work beyond the conventional limits of the still life, which is still the predominant subject of current holographics. These artists are inventing spaces not seen in nature and not seen in any of the arts except perhaps sculpture, the realm with which holography is most easily compared. Photography, on the other hand, is a medium with which holography may be contrasted.

In May 1977, Harriet Casdin-Silver's one-artist show opened at the Museum of Holography in New York City. It consisted of free-flowing, brilliantly colored light abstracts suspended against black backgrounds and illuminated by both long, flowing laser beams and white spotlights, depending upon the original recording methods. Casdin-Silver, an assistant professor of physics at Brown University and a fellow at the MIT Center for Advanced Visual Studies, conducts a course at the Center in holography as an art form. Reviewing her show of abstractions, Frederick St. Florian, professor of architecture at the Rhode Island School of Design, described her works as a "challenge to one's imagination to see through them and beyond them—not unlike the glance through a keyhole—into a world yet to be unlocked and resistant to our comprehension. A world in which artifacts may be formulated through the manipulation of light energy is a most splendid manifestation. The shaping of things without the hindrance of material presence, elusive, transparent, magnificent."

Such glowing terms about glowing images are in marked contrast to the *New York Times* review by Hilton Kramer of the "Holography '75" exhibition at the International Center of

Photograph of Harriet Casdin-Silver's transmission hologram SPHERE, 1977, in its display mount. Photo © 1977 Harriet Casdin-Silver.

Interferometer test pattern (interference pattern), described on page 17. Photo © 1980 Jeff Berner.

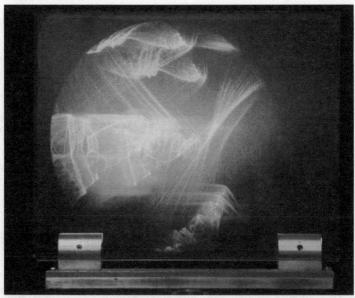

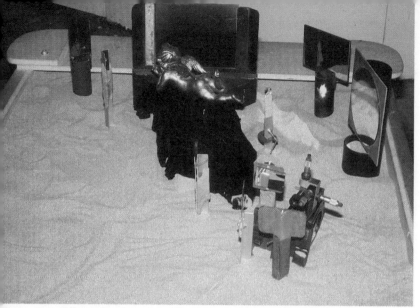

Gilt angel sculpture in position facing holographic plate on isolation table before making transmission hologram (described on page 27), with optical components surrounding. Photo © 1980 Jeff Berner.

Beaming laser. Photo © 1979 Jeff Berner

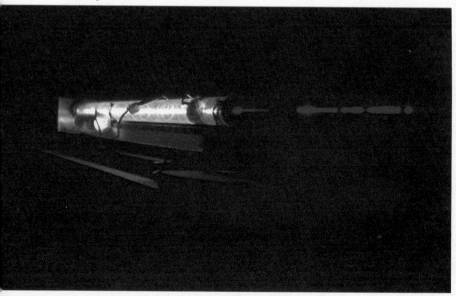

Angel seen from opposite end of isolation table. Laser cover appears in rear.
Photo © 1980 Jeff Berner.

Photograph of reconstructed transmission hologram of angel (see page 27).
Photo © 1978 Jeff Berner.

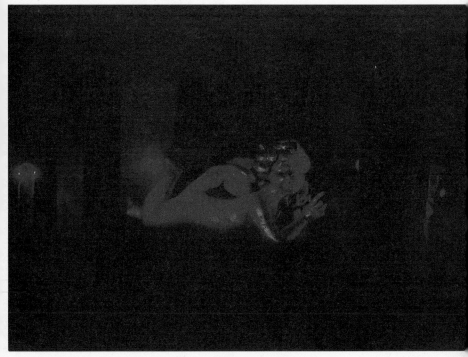

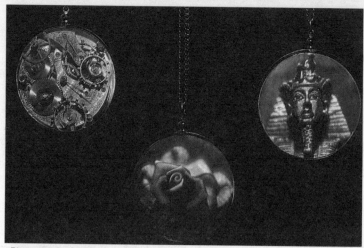

Photograph of reflection holograms (dichromate pendants) by Electric Umbrella. Photo © 1980 Jeff Berner.

Salvador Dali inspects a hologram. Photo © 1977 Steven Borns. Photograph of Harriet Casdin-Silver's laser transmission hologram EQUIVOCAL FORKS (1977). Photo © 1977 Harriet Casdin-Silver.

Photography in the summer of that year. After a scathing catalog of the inherently disappointing qualities of the holograms displayed in the show, particularly the "atrocious" rainbow hues and small sizes of the works, he went on to say:

> What is worse, however, is what might be called the "culture" of holography. It is, to judge by the present exhibition, a gadget culture, strictly concerned with and immensely pleased by its bag of illusionistic tricks and completely mindless about what, if any, expressive possibility may lie hidden in its technological resources. There are, to be sure, a few "artistic" attempts here at abstraction and pop art and the familiar neo-dada repertory. . . . Much of the work in this show has, I gather, been produced not by "artists" but by physicists professionally involved in holographic technology. The physicists appear to favor objects out of the local gift shop, whereas the "artists" do their shopping at provincial art galleries. . . . It is difficult to know which is more repugnant: the abysmal level of taste or the awful air of solemnity that supports it.

Although Kramer's critique may be valid for certain aspects of the exhibition and for the practice of "fine-art holography" in general, it is curious to note that the show he was discussing was mounted in a "center of photography," resulting in the same collision of critical approaches which took place when the photographic medium tried to enter the "art world" of painting. Holographers and critics alike may do well to distinguish carefully among the various modes of artistic expression available to the different media of painting, photography, and holography. In fact, even a tacit comparison in the case of photographic and holographic art may be recognized in years to come as "mere matching," a purely intellectual exercise in the effort to understand holography. Kramer did not make such an explicit comparison, and in fact suggested that a center for photography was not the right setting for holography; not because of its striking contrast to holography, however, but because of the "infancy" of the medium.

At this early stage in the development of fine-art holography it would be well for us to judiciously avoid the obvious temptation to compare the two arts, lest the impression that holography is merely "three-dimensional photography" become widespread. It is already a common notion among nonholographers. Journalists and other observers continually describe it as such, or as cameraless photography. For the time being, however, the comparison is a disservice to holography in the sense that if, by some chance, a

genuine UFO landed in full view of such journalists and critics, it would be immediately compared to an airplane or a rocket, making it somehow more familiar by association and analogy. Such a comparison might also virtually deaden the impact of the utterly new impression an extraterrestrial presence would make upon its viewers.

Holographic art is admittedly moving along slowly, but the techniques of a holographer such as Anait shows that it is also moving along surely. Anait's use of the medium not only includes her playful approach, as demonstrated in her "Space Graffiti" integral hologram, but also the exciting pseudoscopic spaces "carved" out of light by a creative spirit who wishes not only to reflect real things but to create truly new dimensions. What the reviewer cited above never mentions about the nature of the hologram, while finding himself stuck in his disappointment with the "stupefying innocuousness" of the subject matter, is exactly this pseudoscopic aspect possible only in holography. Viewing an object in this way gives the viewer a sense of being inside the form looking out to where the observer usually is! Even a kewpie doll from the carnival midway takes on a thrilling aspect when seen this way. Anait specializes in using this aspect of the medium, "carving" pseudoscopic spaces out of still deeper pseudoscopic spaces by the simple method of placing one hologram, reversed, into the scene on the isolation table, and using that as an object in a second hologram. Theoretically, a "tunnel" of infinite length could be carved out by this method. It would be approximately analogous to the reflections that take place in a barber shop, as the mirror on the wall in front of you reflects the mirror on the wall behind you, except that pseudoscopic space is a kind of "hole in space."

Viewers and reviewers have repeatedly commented that the hologram shimmers before the viewer *like* a vision in a crystal ball, *like* a hallucination, something *like* a dream; and that it *is* a light sculpture. But the qualities which will allow holography to endure are beyond this superficially magical image. The qualities of *spatial relationship,* of "pure-light" luminosity and therefore buoyancy, give holography an impact that lasts far beyond the initial astonishment felt by aficionados of "the new." The late critic and avant-garde art historian Sir Herbert Read once said: "Space is always only a form of the relationship of the ego to the surrounding world. . . . The organization of space, in the architectonic sense, is the process by means of which the subjective feeling for existence is rendered relative and metaphysical."

Rosemary (Posy) Jackson, the founder and director of the Museum of Holography, and herself a widely experienced holographer, said in a *Village Voice* article on January 3, 1977: "The essential wonder I have about holography is that it approaches communication and art from a totally different vantage point. It is a radical change from the Gutenberg tradition of visual literacy which depends on a strictly two-dimensional reality. It is no longer necessary to reproduce the idea of three-dimensional space; it exists as an inherent part of the holographic image."

An active artist-scientist in the field since 1972, and one of the first students to receive a certificate in optical holography from Dr. Tung H. Jeong at Lake Forest College in Illinois, she is regarded worldwide as a leading force in the establishment of holography as an art form. After "Through the Looking Glass" went on tour from the Museum of Holography to appear in galleries and museums across the United States and Canada, Jackson organized the "Reflections of Future Space" exhibition at her New York center, comprising among other things reflection holograms from American artists and some from the Soviet Union.

But exhibitions in galleries and museums cannot alone establish a firm role for holography as a fine art at such an early stage in its existence. The question of holography being a gimmick or an art has been asked about many a new "movement" or medium introduced to the public. It must be asked, but it is also something of a deception as phrased. The question "Is it art?" was raised over and

Series of single frames from original cine film for MARTIAL ARTS (1977), by Randi Garey, produced as 180° and 360° integral (motion) holograms. Photos © 1978 Multiplex Company.

over about photography during its first nearly 140 years, and only in the past ten has the debate subsided, with the notable recent exception of Susan Sontag's challenging essays on the subject.

Rather than asking "Is holography art?" we may reasonably ask in the coming years, "Are artists using holography?"

In 1971, five years before the first Museum of Holography was inaugurated, Lloyd Cross opened the world's first School of Holography across the continent in San Francisco. Since that time he and his associates have given instruction to an estimated two thousand students, some of whom have taught others. Cross organized the school with the specific purpose of not only teaching holography, but of liberating the medium from industrial and scientific cliques by putting it into the hands of artists and others of moderate means.

By 1972 he had invented the white-light integral hologram, and in 1973 he opened the Multiplex Company as an enterprise doing an active business in the commercial application of this easy-to-display holographic "movie." The enterprise was intended to provide an economic base for the fine-art explorations which were of greater interest to Cross, his associates, and students. The Multiplex Company has made holographic movies for entertainers Lily Tomlin and Ringo Starr, for corporate entities such as du Pont and Warner Brothers (*Logan's Run*), for the Edmund Scientific Company and Lawrence Livermore Laboratories' Computer Graphics Group, and for various artists already established in other media, notably Salvador Dali.

It was in response to a request from Dali that Cross set out to devise the technique of recording a motion-picture sequence onto a holographic sheet, to be displayed not by the laser light but by an ordinary uncoated light bulb. The result was a 12-inch-high-by-24-inch-360-degree film which rotated on a motorized turntable and showed rock star Alice Cooper holding a microphone, with Dali-painted brains looming above the singer. Created in 1973, it was the first white-light integral hologram. Another Dali 360-degree film shows the artist painting a portrait of his wife, Gala.

Cross is a teacher in the field of optics and holography, and he is also the inventor of the integral hologram printer (see page 35). He has been the signal figure in the field who has created or refined devices (isolation tables, printers, tunable oil-filled lenses, etc.) which can be constructed from materials obtainable in almost any hardware store, further placing the power of the new medium for information storage and exchange, physical exploration, and artistic

expression into the hands of a broader population than might have had access to it. His having done so at an early stage in its history may have saved holography from becoming yet another closely held tool of the scientific and commercial institutions.

By the end of summer 1976 Cross chose to pursue his inventive, creative, and teaching goals independently from the Multiplex Company, as classic conflicts arose out of the growing demands of the business world and of those interests wishing to corner the market on the techniques of a medium that, by its very nature, has no corners!

Lloyd Cross continues to demystify holography, demolishing its complexity mystique and teaching that anyone of reasonable intelligence and healthy imagination can become an "inventor" in the developing science and art of holography.

The first exhibition of holography as a fine art took place in 1970 at the Cranbook Academy of Art, in Bloomfield Hills, Michigan. Twenty-seven holograms were shown in an environmental setting. Holograms were raised on poles which were stuck into small sand pits, and illuminated with white light and with lasers. The images appeared to be floating in space in the darkened surroundings. Works by Cross, Alan Lite, Jerry Pethick, and others drew thousands of spectators. The guard for the show usually stood close to Cross's transmission hologram of a champagne glass, next to which stood a real champagne bottle. As viewers filed past, he stuck his finger into the "bubbly" and licked it, saying softly, "Dry champagne!" When Elayne Varian, curator of the Finch College Museum of Art in New

York, saw the show, she invited the exhibitors to open at the Finch later that year.

The Finch show included images by artists already firmly established in the fine-arts world through other media, notably Robert Indiana, whose famous LOVE sculpture was recorded holographically and displayed in the show. The exhibition was reviewed in every major art publication, and the *New York Times* was moderately excited by the new medium. It was a review in *Newsweek,* June 15, 1970, that really welcomed the baby into the world. It said, in part:

The movies (in 1894) brought fluid, continuous movement to photography, a quality that in time revolutionized the sensibilities both of those who made and those who saw film. The "hologram"—an entirely new medium for painters and sculptors as well as filmmakers—brings something equally important: when illuminated by laser light, the holographic plate projects three-dimensional images, rounding off what seems perfectly flat in the conventional photograph. These images are so real, visually speaking, that the viewer can move around them as though they were objects, seeing new angles as he moves.

The review closed with:

Gerald Pethick turned to holography as a means of reproducing his own sculpture; now he is planning exceptionally complex forms that will be in large "real" scale, perhaps three feet by three feet before the eye. He is finding a way to a new esthetic, an esthetic that preaches solidity while it practices the immaterial and the insubstantial: the impossible, in brief, made possible. There is the barest hint of such wild directions at Finch College, playing in and among those tiny (holographic) screens, but the hint is there and likely to project itself into our lives sooner than anyone now believes.

The world's largest exhibition of display holograms took place in Tokyo during a two-week period in August 1978 at the huge Isetan department store. Ninety holograms by as many holographers from around the world attracted more than fifty thousand viewers. The show was titled "Alice in the Light World: An Exhibition of Holography Today," and its "mascot" was a pulsed transmission portrait by Peter Nicholson which depicted a young blond-haired girl (see page 91). Her pupils were rather dilated, a common effect caused by the low-light conditions of the holographic portrait studio, which gave her a haunting expression of wonder.

57

The exhibition, sponsored by *Asahi Shimbun,* one of Japan's largest newspapers, included examples of all major varieties of hologram, with nearly half produced in Japan. Some novel mixed-media examples were displayed, such as Kohei Suguira's pair of sunglasses, in which the lenses themselves are holograms. Three-dimensional images can be seen by people looking at the wearer.

One of the most striking holograms came from France, depicting "Venus de Milo" standing more than eight feet high. Another holographic "statue" was "Aphrodite," by Stephen and Jeanne Benton of the Polaroid Corporation.

Support for this enormous public showing came from the Japan Society of Applied Physics and from the Japan Society of Image Arts and Sciences, and it was installed with the assistance of Holomedia, Incorporated. Participating artists included Anait, Rufus Friedman, Tung Jeong, Harriet Casdin-Silver, Hans Bjelkhagen, and Peter Claudius.

Although there is currently nothing resembling an established collectors' market for holograms, the day may not be too far off when owners of early holograms will find that their value has appreciated exponentially. Daguerreotypes and other kinds of early photography are bringing extremely high prices on the collectors' markets, but even in that medium it cannot be said that a firm market exists. However, it required nearly a century and a half for conventional photography to achieve the kind of status it currently enjoys. Holography promises to do so in a very much shorter period of time, if for no other reason than the fact that cultural evolution has been vastly accelerated through the stimulus of technology and the information explosion it has spawned.

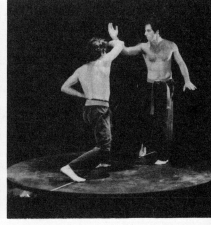

One intensely focused area of holographic art which promises to play a role in the development of the collectors' market is that of erotic holography. California holographer Peter Claudius's show at the Museum of Holography in New York City in the fall of 1978, "Lunch Box Review," attracted very large audiences. One can barely imagine a more powerful combination of attention-riveting visuals than that of etheric, radiant holograms (many in motion!) depicting earthy and humorous elements of realistic erotic situations.

Hugh Hefner, the Chicago publisher, is rumored to have the largest single collection of holography in the country.

The humor of the collecting question is because holography is past its infancy but still in its adolescence, almost any image created by a holographer anywhere in the world is likely to be a "first" of one kind or another. This can easily confuse the collector and prevent an informed market from developing for some time to come. It is unlikely that holographers will imitate one another as much as photographers did in the early years of that medium when there were hundreds of thousands of cameras in use by those caught up in the photomania which swept Europe and America in the mid-nineteenth century. Holography is still a rather inconvenient medium, and anyone who takes the time to holograph is likely to attempt something original. Except for a predictable obsession on the part of holographic hobbyists with watch parts and skulls, almost every hologram created for some years to come will be the first of its technique or of its content.

In a 1977 article in *The New York Times,* writer David L. Shirey said:

When we consider that the hologram is in its teens, we must say, I think, it is doing quite well for its age and it promises to mature rapidly if its development over the last decade is any indication of what it can do in a short period. . . . There is every reason to believe that the laser light will be for the hologram artist what oil has been for the painter, marble for the sculptor, film for the photographer and the movie-maker.

The sights seen in holographic art, from the "inside-out" pseudoscopic spaces "carved" out of light to the abstractions and distractions of artists entering the medium from the other arts, are sufficiently delightful and instructive for many in the field. But it is the interacting forces of living light and the thought behind the techniques involved that imply the opening of a luminous frontier where the motive forces of artistic and scientific inquiry have joined once again.

HOLOGRAPHY
AND CONSCIOUSNESS

There was a child went forth every day,
And the first object he looked upon, that object he became,
And that object became part of him for the day
 or a certain part of the day,
Or for many years or stretching cycles of years.

—*Walt Whitman*

Photograph of transmission hologram THOUGHTS (1973), by Kenneth Dunkley. Photo © 1976 Steven L. Borns.

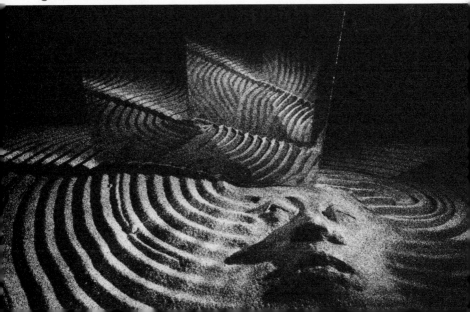

The image may be exploding, as described at the outset of our exploration into the unique field of vision known as holography. But just what is it that is exploding?

An image is, by definition, an imitation representing something else. An image is a real phenomenon, a sensory event, but an image is not identical to the thing it represents. A conventional photograph is a real object, but is rarely taken to be the thing of which it is a record. A hologram is a real reconstruction of a sculptural image, but is not actually the object that it imitates. The map is not the territory.

Now, looking and seeing serve an infinite variety of purposes, and are largely unconscious or automatic. Insects and animals look and see, and probably don't think about it. But humans are equipped with a self-reflexive function of mind which provides an ability to "see ourselves seeing," to experience self-consciousness. Let's look briefly at some aspects of seeing as they relate to the human encounter with the hologram.

Because the hologram is truly dimensional, contemplating a holographic reconstruction can stimulate what is known in visual studies as the Gaffron phenomenon. Depending upon just where visual awareness is focused, a viewer can experience varying degrees of emotional satisfaction as he or she "devours" an image. A pear is used to illustrate the phenomenon.

If visual awareness is centered on the near side of the pear, it is perceived "exteriorly," and the noticeable qualities of the object are the form, the surface contours, its distance from the viewer, its separateness from the observer. When awareness is focused on the far side of the object, however, perception of the pear shifts toward its weight, volume, and "inner" aspects, as the viewer incorporates the object into the boundaries, the spatial zones, of the very self. The viewer devours the image, or *brinks upon* making the object a part of himself, as these two modes of attention are employed. In laboratory experiments on human volunteers, muscle tension and relaxation are noted to shift between these modes, even though the objects used are not actually edible. The "grasping" starts when the eyes fall on the near side of an object, and the more passive mode of "mere looking" takes places as the object comes closer and closer to becoming an "interiorized" part of the viewer.

For many centuries poets, mystics, and now psychologists have understood that in a sense we become what we behold. Currently we are surrounded by a visual wraparound which is "amplified" and accelerated through a vast array of technological means, and this wraparound is coated all over with images ceaselessly popping into

our view, present in waking and sleeping, and in isolated darkness. It often takes the wave of a hand, a bright color, a blinking neon sign, a charged symbol such as a cross or a crescent, or a sudden motion to arrest attention even for a moment. With the apparent science-fiction-like takeover of a large amount of human living and looking time by various media—most notoriously color television—the average person may have all but lost the ability to concentrate visually on anything for an extended period of time without restlessness and discomfort.

But for those motivated to "ride the tiger" and achieve some measure of ability to focus visual (and therefore mental) attention, visual meditation provides a method of attaining such self-control. The hologram provides an ideal object of visual meditation, as the "shrine of light" seen in a hologram (no matter what the image) serves as an almost immaterial center of focus for the meditator.

The French author Gaston Bachelard, in a particularly memorable passage in his study *The Poetics of Reverie,* describes the magical relationship which can occur between the seer and the seen:

Suddenly an image situates itself in the center of our imagining being. It retains us; it engages us. It infuses us with being. The *cogito* is conquered through an object of the world, an object which, all by itself, represents the world. The imagined detail is a sharp point which penetrates the dreamer; it excites in him a concrete meditation. Its being is at the same time being of the image and being of adherence to the image which is atonishing. The image brings us an illustration of our astonishment. . . .

A flower, a fruit, or a simple, familiar object suddenly comes to solicit us to think of it, to dream near it, to help it raise itself to the rank of companion to man. . . . Not all the objects of the world are available for poetic reveries. But once a poet has chosen his object, the object itself changes its being.

Although concentrated gazing upon graphic mandalas or actual objects such as a single flower or the tip of an incense stick has been practiced since time immemorial, especially in Eastern religions, not until the advent of the holographic image has it been possible to gaze upon three-dimensional images which are as light as light, things through which one's own hand may pass. The hologram, at this point in our visual history, is still such a "separate reality" that its freshness, its origins beyond the otherwise oversaturated morass of pop culture and pop technology, give it a quality many steps beyond our usual experience. As we have seen,

holography is being increasingly used to transfix the consumers' attention, on the one hand, and to express artistic visions on the other. Both modes involve a kind of staring, and for years to come holograms will be "devoured" by seekers after new sensations.

Fortunately, the remarkable nature of the hologram is not only experienced through gongoozling, that "one-pointed" visual contemplation referred to so often in our current exploration. Because a hologram is an experience of space both in the external world and in that of "inner space," the observer may enhance the feeling for both the object of contemplation and for the depth of the mind itself, and the way in which we ourselves blend with forms perceived. In the Japanese martial art of Aikido there is taught a method of seeing known as having "soft eyes." Rather than looking fixedly at an opponent's face, or hands, or feet, an aikidoist is taught to gaze *generally* at the zones occupied by the opponent, visualized as a large bubble or sphere. The aikidoist also occupies such a sphere. In this manner, one does not become hypnotized or fixed on any single aspect of the opponent, but can expand vision beyond mere visual focus to a diffused, "equalized" view of the energies confronting him or her.

Taking a "soft-eyes" approach to the otherwise fascinating images projected by holograms, a meditative viewer may situate himself comfortably in the presence of a hologram of choice and avoid looking directly at it. Rather, the soft-eyed viewer can sit with the image apprehended in peripheral vision, feeling the presence of the image and its qualities of light, sharing time and space with it. This may be seen as "democratizing" the relationship between the "superior" viewer and the "subject" of observation. It equalizes the energies of both the seer and the seen.

In biofeedback, which helps an individual monitor and therefore alter a variety of physiological responses, a somewhat related concept known as passive volition is used. This suggests avoiding trying hard or trying at all to change muscle tension, heart rate, or body temperature because the self-consciousness of trying divides the individual into the one trying and the one performing. So, by an attitude of passive volition, or very relaxed willpower, the biofeedback student can get in touch with physiological functions previously thought to be autonomic, but known by accomplished yogis to be under personal control.

Practicing passive volition and soft eyes may lead toward a more comprehensive manner of seeing, rather than the one-pointed (even when scanning) looking which most of us do. Sitting "with" a

hologram as a companion presence will enhance the recognition that one is also a sculpture of light, of energy, and this can become a deeply peaceful and satisfying method of knowing a hologram far beyond that experienced when it is made into a mere "subject" of observation. Wordsworth wrote in "Prelude II":

> Bodily eyes
> Were utterly forgotten, and what I saw
> Appeared like something in myself, a dream,
> A prospect in the mind.

From the visual to the visionary, the quest for enlightened perception is not concluded in creating imagery or in seeing visions. Beautiful pictures, "deep views," shimmering presences do not, in themselves, create insight. In both ancient and modern Islam representational imagery is largely forbidden because it is feared that if one is in the presence of images too specific or too lovely, attention and consciousness will become stuck at the edges of the material world. But images approached in the right spirit may stimulate insight beyond the realm of sight, just as language may evoke understanding beyond the realm of description or discourse. As both Eastern mystics and modern physicists have shown us, the universe itself is a "verb," a process. "The train of events arrives at no station," as Alan Watts, the late Zen philosopher once put it.

Beyond holographic imagery, and reflecting on the very processes that lie behind it, we may have an appropriate analog for the both ancient and modern understanding that every event is inextricably related to every other event. Just as the Taoist and Zen philosophies have celebrated the interconnectedness of all things physical and spiritual, so the hologram in its interference pattern shows us the intimate weave of form, appearance, energy, and the "events" and "things" swimming in the vast ocean of the apparent.

Such wholeness seems alien or suspect to anyone who has not experienced it in a sudden Zen-like glimpse of recognition, or in the ecstacy of ritual dance, or in the various unifying practices of yoga. Yet the hologram can be seen as a symbol of such wholeness, as a single piece of hologram contains all the information "known" by every other part of it. If the hologram were actually alive, viewing it would be roughly analogous to millions of people sitting in bleachers looking at a monumental sculpture. Every individual would be seeing the same sculpture, but from slightly varying angles. Even if all but one spectator were removed or "cropped"

from the stadium, that one remaining person could still describe the sculpture, although only from his particular vantage *point* in the stands.

Although high-energy physics has demonstrated the interconnectedness of the world, at both the level of atoms that chain-react and of people everywhere who are woven together by the common threat of nuclear annihilation, it is difficult for anyone but the pure physicist or mathematician to see the beauty in this living lesson in wholeness. The hologram, on the other hand, provides a gorgeous study in interwoven energy sprays, of interference fringes creating "deep information" clusters which *both imitate* and *are aspects* of the manifest universe. The hologram is a true window through which we are now exploring the "immaterial" aspects of the outer world, as well as the deep dimensions of inner space. Those inner dimensions are considered in some proposals by Dr. Karl Pribram, the Stanford neurophysiologist.

In a headline we might expect on the front page of *The Daily Planet* in Metropolis, July 4, A.D. 2000, the *Brain/Mind Bulletin* announced in its July 4, 1977, issue, "Primary reality may be frequency realm, theory says." In an editorial in that issue of the *Bulletin,* Marilyn Ferguson put Pribram's theory in a nutshell: "Our brains mathematically construct 'concrete' reality by interpreting frequencies from another dimension, a realm of meaningful, patterned primary reality that transcends time and space. The brain is a hologram, interpreting a holographic universe." Pribram, as a renowned brain researcher, has accumulated evidence for more than a decade indicating that the brain's "deep structure" is essentially holographic. He speculates that the nature of the universe is a realm of frequencies and potentialities underlying an illusion of concreteness, pointing out that ever since Galileo science has objectified nature by looking at it through lenses. Pribram was struck, in conversations with his son, a physicist, by the idea that the brain's mathematics might be a crude form of lens. Aldous Huxley, in his pioneering work on the psychedelic experience, *The Doors of Perception* (1954), suggested that the brain is a highly specialized, very limited reducing value which essentially cuts us off from the big picture. Pribram speculates that reality isn't at all what we see with our eyes, and that if we didn't have to peer through the "lens" of our brains we might know a world organized entirely of frequency domains interacting to produce events. No space, no time, just

events in the kind of flux that Eastern philosophies have taken for granted for centuries. Transcendental experiences induced through deep meditation, biofeedback, psychedelic substances, and spontaneous "realizations" suggest that when a slight tear occurs in the veil of illusion, something quite awesome and "vastly interconnected" leaks through to us; we become aware that we contain all, and that all contains us. This wholistic, holographic concept may serve to "explain" paranormal phenomena such as precognition, ESP, and other verified phenomena which, because of their possible existence in the frequency realms, are hard to "prove." Theoretical physics, as mentioned earlier, has already demonstrated that events cannot be described in mechanical terms at subatomic levels.

Response to that special issue of *Brain/Mind Bulletin* was so broad that it was reprinted four times, and currently more than twenty-five thousand copies are in print.

In the November 1977 issue of *Holosphere,* Eugene Dolgoff, who has been involved with holography since 1964, and whose interdisciplinary background includes electronics, physics, optics, electro-optics, and psychology, wrote a long article on the increasing acceptance the holographic model of the brain and the universe has gained in recent years. He wrote, in part:

In 1971, physicist David Bohm, who earlier worked with Einstein, suggested that the hologram was a starting point for a new description of reality which he called the *enfolded* order. "Classical reality has focused on secondary manifestations—the *unfolded* aspect of things, not their source. These appearances are abstracted from an intangible, invisible flux that is not composed of parts; it is an inseparable interconnectedness.

Primary physical laws cannot be discovered by a science that attempts to break the world into its parts.

Dolgoff further reports on the thinking of the late Itzhak Bentov, the scientist/inventor whose *Stalking the Wild Pendulum: On the Mechanics of Consciousness* appeared in 1977. According to Bentov:

We can use the analogy of a human body. . . . We know that each of our cells can produce a human being having the same physical characteristics as the original . . . and therefore a holographic storage of information would imply that since we are a part of the universe, we also contain all the information contained in

the universe itself. So in order to know the universe, it's sufficient to know ourselves very well. If you know yourself, you should know all about the universe. And that is what the ancients are saying, really, when they talk about finding the universe in a grain of sand.

Holography has implications on a less cosmic scale, especially regarding human memory. Pribram's theories, among others, suggest that the brain contains holographic imprints of everything experienced; we have heads which are considerably larger inside than out, containing friends, Hawaiian beaches, the moon, and so on, resting comfortably in billions of synapses, or neural patterns, to be played back on call, albeit imprecisely. "Photographic" memory is really holographic memory.

Although a full exposition of these theories and their possible implications is beyond the scope of the present book, it is clear that holography is giving strong hints to investigators that the universe is a vast tapestry of interference patterns, only a small portion of which is available to the eye, but all of which is interacting with us in subtle vibratory forms. The fact that each of us "grew our own brains, grew our entire selves" from the beginning of just a single cell which itself "knew how" through its little packet of DNA, is quite exciting. The developing holographic view of our brains and of the larger world and universe suggests that the individual may not "know everything," but does indeed have connected *access* to everything.

The magic windows of holography look out onto or into territory that is so new that one's spirit leans toward it with such visual delight and intellectual anticipation that those projecting their spirits into horizons "away yonder" cannot know any longer whether they are falling into or out of the frame. As Buckmkinster Fuller pointed out many years ago, "in" and "out," and "up" and "down" mean nothing anymore, and holography has brought this home to scientists, artists, and mystics alike.

When the Tasaday natives who live in caves on the South Pacific island of Mindanao were discovered only a decade ago, a reporter asked their tribal poet, Balayam, to define the human soul. Balayam replied quietly, "The soul may be the part of you that sees the dream."

OTHER VOICES

Single frame from original cine film for KISS II, 1974, 180° integral (motion) hologram by Lloyd Cross. Photo © Multiplex Company.

Because the inherent nature of the hologram is to record a seemingly infinite number of points of view, an invitation was extended to active holographers from various points on the planet to contribute words and images, ideas and opinions, announcements and predictions about the medium. Here are twenty-four "Other Voices" from the growing international holographic network.

What's so fascinating about holography?

I think my first answer would be to generalize the question. What is it that keeps so many people who come in touch with it so involved with it? What is it about it that's such an instant hit? Even though it's not a highly remunerative endeavor at this point. And even though it's extremely difficult to exhibit the works of your art. Despite that, it's been true for me and for a lot of people I know that once they get into holography they simply stay there for long periods of time. In fact, the history of holography is so short that I can say that almost all of them are still there.

It has so many dimensions that it is not just a field in the common sense of the term, as compared to its nearest comparison which is photography. It has not just one more dimension beyond photography—but it has, I like to say, N-dimensions. The holographic image is not just another view or another dimension of a view, but a million views, a million separate photographs.

Another answer to the question, one of the sort of characteristics of the people who get stuck in holography—what they're stuck on is its simplicity. People are amazed by the simplicity of making a hologram. Amazed, intrigued, entranced by the basic simplicity of recording in this way, with interference fringes, realizing that the complexity of it is in the verbal thought of it—and not in the actual physical reality of it. And the making of a hologram, the repetition, the creation of art within the holographic domain reinforces that, and as soon as you're into that process far enough, which isn't too far, you really get stuck in this, you really realize that this is, number one, an intriguing medium of many, many dimensions, many different things to do, many different holograms to make, all different kinds of media within the one medium, each with its own sort of expressions that you can think of, ranging from the immediate first-of-a-kind to the ultimate dream, ultimate artist's dream—creating perfection within a medium. That combined with its unbelievable technical (I even hate to use the word technical), let's say, physical simplicity and its basic nature dealing with light itself in such a simple way, which in fact proves that light is indeed simple, not complex.

Holography is a doorway to the ultimate physical reality . . . of the physicist. That's an important point, this physical reality up to now has belonged only to the physicists. Holography opens it to

everyone, the doorway for everyone to see into physical reality as clearly, and in fact (by ignoring the verbiage and the mathematical symbols), *more* clearly than even a physicist. And the holographer is one who creates such a thing. And the doorway has all the imagination of whatever endeavor an artist is into, how many years a person has put into one specific aesthetic, and his desire to perform an artistic act. To me it begins in the mind of the artist and ends in the mind of the observer. Holography is a medium of sufficient depth to carry the full message of the mind. It is a rich medium, a deep medium, a many-dimensional medium; that's why it's the first medium that is a true doorway. It totally encompasses the two dimensional in multiples, millions of two-dimensional images, and totally encompasses the linear in megafeet of thousands. Thousands of pages, millions, billions of words per hologram, per separate piece of medium. The technique of making such a thing through such simple ways, which holography has made evident through the work of many people, but mostly through the work of artists.

Primarily it has been the work of artists that has literally developed holography's basic simple form that allows you to interact directly with the physical world, and understand laser light in its patterns of interference without ever thinking about its mathematical verbiage. Rather than dealing with the uncertainty principle on the one hand in the microcosm and cosmological constants in the macrocosm, which is what science deals with, which popularized science . . . which is a mystical consciousness, the holographer deals directly with a bed of sand and a plate of chemicals and a tube filled with glowing light. He deals directly with physical reality. True alchemy. The original purpose of alchemy, which is to understand the four basic elements, the composition of four basic elements: earth, air, fire, and water. And that's where holography has led me actually, to those four basic elements, to realize that everything that we can possibly need is contained either in the earth, the air, or in fire or in water. All the things that we presently use, all the cars we drive, the oil we burn, clothes that we wear, the roofs we live under, the rugs we walk on, come from the earth . . . and are dissolved in water and the various kinds of earth, atoms out of the earth. And they're energized by the sun in various chemical forms, and heated by fire at various temperatures.

A technology is a specific manifestation of physical reality, of what's possible. What's been developed on this planet today is one specific technology. Holography can easily project you out of that

specific technology. I think that is what it has done for a lot of holographers. That's what it has done for me, at least. That's why going back to your original intention which was directed to me—why am I interested: basically, the more time I spend in holography the more holograms I want to make. And I've already got a list of holograms that I haven't made as long as your arm. Longer. I mean I can't remember them all. Holograms that I want to look at. Period. There are holograms that I want to see, holograms that I thought about doing and just want to see them, and I fully intend to someday, and they are always in specific medium holographic forms that I've done, that I'm ready to do, but I keep uncovering new forms of holography. An image plane is different from the projected image of a transmission hologram, both of which are different from an integral hologram, each one is a different thing. In each one of those different forms of holography is a number of holograms that I want to make. And haven't made yet. Specific holograms within those different forms.

My problem now is that I've already got so many holograms I want to make that I'm beginning to hate to think about new *kinds* of holograms. Really. I've still got holograms that I haven't made that I want to make. So I'm beginning to think about spending some time, and this is what I plan to do: go back and make at least three of the holograms I've been wanting to make in each different medium. See, I've got all that to do. In the meantime I've got to support myself by teaching other people holography or by making holograms that I'm sure I can sell, or consult, or form some sort of service.

Lloyd Cross is the director of the School of Holography in San Francisco, California.

DAN SCHWEITZER

Within the irony and paradox inherent in holography the artist constructs a real and virtual universe—illuminating a fresh understanding, a new way of seeing seeing.

It is a modern mirror of the human unconscious—not simply three-dimensional pictures, but multidimensional light sculpture, at times obscure, other times frighteningly lucid. I think we now have a shorthand method of depicting imagination itself—a capability of transcending the obvious.

Holography to me is a way of depicting those nonspace, nontime pulses between the fabric of our recognized reality—an entity where anything is likely to happen, where the inadequacies of trust can, once and for all, be confirmed.

Dan Schweitzer is the director of the New York Holographic Laboratories, New York City.

KENNETH JOHN DUNKLEY

Comment on the Work "Thoughts"

I see "Thoughts," now, as a celebration of consciousness. Its particular elements and relationships were motivated by the idea that any arbitrary subset of life can also represent the whole. In this instance, sand, my daughter's beach rake, and a holographically winding staircase where chosen. The only requirement imposed on the individual levels was that they should relate to each other through continuity. At first, I imagined about twenty or so spiraling holographic steps where the viewer of any given one would see only the four steps or levels below him. He would not necessarily know of the development which led to the levels in his view nor of the future evolution of those levels.

The early steps were to be practice stages where I would develop the mood of the image and see what would or would not work. But after only three steps, and time running out, I was forced to effect a hurried closure with the fourth. "Likable but not lovable" pretty well summed up my feelings at that time, though admittedly I was thoroughly chilled and somewhat in awe of it.

After deciding to develop it still further, it was placed in a drawer to wait out completion. I did take it out to show people, inasmuch as the image was fascinating whether I thought it finished or not. During these early months, with no title or mutually accessible language, the two most often asked questions were "What am I seeing?" and "What do you mean by it?"

It did grow on me though and one evening, four or five months after its construction, I conceptually realized the image for what it really was: a three-dimensional representation of the flow of our thoughts. In one moment, each element fell into place with a

73

meaning and purpose as if planned in advance all along. And that the image *per se* cannot exist in our own physical space is as it should be.

Kenneth John Dunkley is a holographer living in Philadelphia, Pennsylvania. A photograph of the hologram "Thoughts" appears on page 60.

RUBEN NUNEZ

A NEW ART to EXPRESS the COSMOS

> Science of life needs the intuition of
> the artists, and vice-versa, the artist needs
> science that can bring him new materials by
> which he can improve his creative capabilities.
>
> —*Aldous Huxley*

The prehistory of holography starts in stones, caves, and caverns. We can still see them today in many parts of the world: Altamira, Spain; Lascaux, France; Vigirima, Venezuela.

The history of holography begins with a tri-dimensional image, made by the scientist-artists, Emmett Leith and Juris Upatnieks (1964), who composed a scene with a "bibelot" bird in porcelain and a model of a toy train. The image has deep insight and clear textures like the "still lifes" of seventeenth-century Dutch paintings. The scene and the subject are in transparent full red color. This was the result of the application of the continuous-wave helium neon laser to the principles of wave front reconstruction advanced by Dennis Gabor in 1948, called by him "holography," or "tri-dimensional laser photography," or "lens-less photography." Leith-Upatnieks improved the use of holography as documentary expression, like "The Roofs of Paris" and "The Lonely Man" in the times of Niepce-Daguerre at the beginning of photography, and "Workers Leaving the Factory" by Louis Auguste Lumière, during the advent of cinematography.

During the first decade of holography: portraits, toy trains, and chess pieces were the central motifs. Holography as an art form has been developed more recently: new styles, new concepts, are

beginning to emerge.

In my case, the works "Crystal from Planet Rainbow," "Principia Planetarium," and "Little King Sasanian," made in Paris during the spring of 1974 and exhibited in New York in 1975, were the result of my research and experience with Kinetics and Glass Art (St. Louis Island 1950–53, and Murano, Italy, and Chacao, Venezuela, 1956–68).

The laser images made with Professor Jean Sagaut were called "holokinetics"—holo (complete) kinetics (study of movement). These images were conceived and composed as optical instrument-models, becoming an entire part of the setup of the holographic camera. The colors composed of pure energy, with the participation of the viewer moving from side to side, up and down, trying to reach the impossible of the seen and unseen, proposes for the viewer more insights of the cosmos.

The antimatter and pure light energy, gardens of opals, new gems, energy of gold, ghosts of the subconscious universe.

The union of physics and metaphysics in the image, the *enfolded order,* a holographic theory described in *"holosphere"* by the physicist David Bohm, who earlier worked with Einstein, suggests that the hologram was a starting point for a new description of reality which he called the *enfolded order.* "Classical reality has focused on secondary manifestations—the *unfolded* aspect of things, not their source. These appearances are abstracted from an intangible, invisible flux that is not composed of parts, it is an inseparable interconnectedness."

Different times and art styles have always had a constant progress in physics-metaphysics of tri-dimensionality.

In the literary world, William Shakespeare in *Macbeth* (1605–06) Act II, Scene 1, produces a verbally visual prehistoric holographic image:

> Is this a dagger which I see before me,
> The handle toward my hand? Come, let me clutch thee:
> I have thee not, and yet see thee still.
> Art thou not, fatal vision, sensible
> To feeling as to sight? Or art thou but
> A dagger of the mind, a false creation . . . ?

In 1917, after the Russian Revolution, the Suprematist Movement was formed by a group of artists: Kasimir Malevich, the founder, Tatlin, Rodchenko, Lissitzky, Puni, Popova, Stenberg,

Exter, Larionov and Goucharova had the absolute conviction that the totality of art can be, and must be, concentrated exclusively in the arrangement of unembellished geometrical forms. Like the *oeuvre* of Lissitzky's *Floating in Space* (1920) where he wrote annotations in the image:

Construction floating in space, propelled together with its spectator beyond the limits of the earth and in order to complete the spectator must pivot around the axis like a planet.

As the tele-energy of Gustav Meyrink, German writer (1868–1932), who wrote: "To pass the ghosts, to go through impossible sides, to discover at the other side another human dimension, the apex and the abyss of consciousness, until this moment have been rarely explored in art. Probably because they appear in such infrequent intervals that humanity cannot remember them, that is why we consider each time as a new phenomenon, never experienced before."

New holographic theories will expand art and technology rapidly, because as René Magritte said: "The visible presented by the world is rich enough to constitute a language evocative of mystery."

Ruben Nunez is a Venezuelan artist working and exhibiting in a variety of media, currently on an extended visit to the United States. Below: at work in Paris, 1974. Photo © 1974 Fina Torres.

STRAWBERRY GATTS

I believe that in the future healing will be done with laser light. There is a very old tradition of disease and a corresponding healing color (or wavelength). The only tools available were the sun and tinted glass, with all the varying imperfections of that glass. By this I mean that glass or plastic transmits light inefficiently due to all of the different kinds of light and heat present in the white light of the sun and chemical-molecular imperfections of the glass or plastic. Today with the use of a laser we may absolutely control the intensity of light at whatever wavelength we want.

Try to explain a hologram to someone who has never seen one. There is no way that person can understand what you are trying to say, as there is nothing in his experience that can be related to what you are trying to tell him. Holograms are the first *visual* piece of the "New World" we have just entered. There is no past history or legends of such a thing, except as a dream of everyone to see, make, or possess a three-dimensional image. Holography is related to some other areas of expanding awarenesses of realities that are appearing on levels such as music (relation of vibrations to emotions and physical forms of matter), acupuncture ("electrical" circuits within the human body; and all living things including the earth), and Kirlian photography (visual evidence of relationships of color and vibrations).

Holography is ushering the world into the Age of Light, for we who are working with lasers are truly "Children of Light."

Strawberry Gatts is a Los Angeles, California, holographer.

EDWARD A. BUSH

Holography is well on its way to becoming one of the newest pop technologies, but it is encouraging to see that public interest is not only superficial. As editor of *Holosphere*—the newsletter of holographic science, technology, and art—I report on holographic research and new applications of holography for an audience composed largely of researchers, engineers, and business people. Over the past year, though, I have seen a dramatic increase in the number of readers whose interest in holography is purely personal.

Some are independent holographers, others are holographic hobbyists, and quite a few merely want to know what will happen next. People with this level of continuing interest are essential in forming the broad base of support holography must have if the pace of its development is to quicken. That they exist is a heartening sign that the full potential of holography will yet be realized, permitting us all to enjoy the multitude of benefits it will provide and enabling holographers to create images they now only dream about.

Edward A. Bush is a New York holographer, editor of *Holosphere,* and information director for the Museum of Holography, New York City.

BRITTON ZABKA

In this age of great technology the birthdate of holography was inevitable. Yet, as an expression of the creative mind, holography still retains that purity which Michelangelo found in a piece of marble. As an artist creating into the infinity of a white canvas or forming the grace of molten bronze, different media are like using different instruments of an orchestra to create the needed communication inspired by the greatness of the universe. A painting can show invisible energy patterns of emotion going dimension into dimension with color and pattern, or a bronze statue can stop and recording for eternity the highest balance spiral path of a great gymnast such as Nadia.

Holography is like an entire orchestra. Holography has given me the opportunity to go into the third dimension of space on the energy fields of a canvas. In 1976 at the Multiplex Corporation in San Francisco I created the first 360-degree animated integral hologram. A limited edition depicting the universe, which exists in the mind. Concerned about the wasted space that could be utilized in holograms, I concentrated on a number of integrams using volume and space to its maximum capacity. Exhibiting and sharing holographic art in many international holography exhibits in major cities for the last three years, I have found in the field of holography the opportunity to meet and interact with many fine artists and scientists. I have now established the first Midwest dichromate company for producing holographic artwork called FALCON (Fine Art Laser Community). Falcon is the ancient symbol of the sun.

In the future I would like to continue working with scientists and

physicists in developing holographic moving images that can be projected into space, so that people can create more visually with multimedia, projecting holographic images through an audience and breaking down the barriers between performer and audience. In the future there is also the possibility of creating lasers from solar energy with parabolic mirrors to carve statues with light and also the creation of holograms from sunlight by making ambient light coherent. Problems of the light oscillating between mirrors, etc., have to be taken care of, but it should prove to be a large breakthrough. FALCON is presently working on the world's first dichromate white light reflection integral hologram.

I am presently involved touring university and college campuses, making TV appearances, and the holographic art which I have contributed is being used to share with students to inspire and stimulate advances in holography not yet attained or thought of. Holography already incorporates our present lives and has many openings for new careers and interests for the future in all fields.

Britton Zabka is a holographer and the founder of FALCON, Charleston, Illinois.

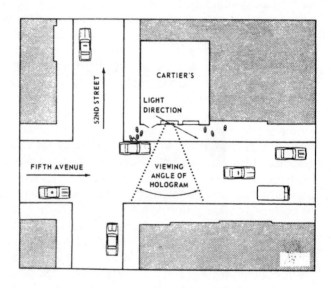

Photograph of real-image projection hologram by Robert Schinella, displayed at ▶ Cartier's, NYC, 1972. Photo © 1972 Robert Schinella.

ROBERT SCHINELLA

Throughout the centuries man has developed many techniques to record the objects and events around him. Prehistoric man, scratching with charred sticks and colored sands, etched his thoughts on the walls of his dwellings. Today we are witnessing the development of what may be the ultimate step in visual recording: holography. The cycle is complete; the charcoal drawn from the fire has given way to the fire itself, and now man sculpts with the sun.

Robert Schinella is a painter, photographer, and holographer who has been involved with the latter medium since 1965. He has produced numerous holograms in his own studios, and has lectured widely on the art and science of holography. He lives in New York City, where he is a consultant on the subject.

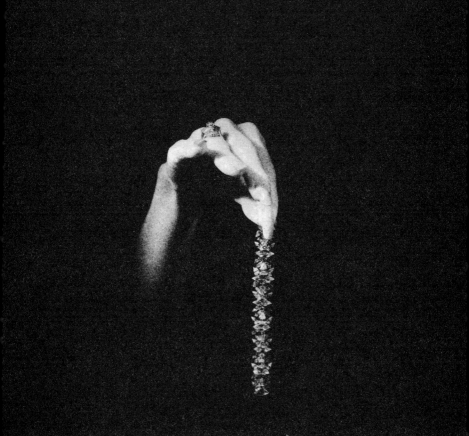

LARRY LIEBERMAN

"UNIVERSAL MAN and WOMAN"

In the hologram "Universal Man and Woman" the gaps which lie between tradition and progression and between man and woman have been closed. They are one and the same—wholly. As a hologram, "Universal Man and Woman" is three-dimensional visually as well as in concept and philosophical implication. Man and woman are depicted as cosmic beings, together on their journey through infinity. Enclosed in a molecular sphere, they are the atoms which unite to complete the endless chain of evolution.

In reference to Leonardo da Vinci's *Diocletion Man*, "Universal Man and Woman" updates the concepts of universality and beauty. Leonardo presented only a man in his concept of perfection, completing only half of the total sphere possible. Man is only one wing necessary for flight through time. The other wing needed is woman. Both are equal in weight and responsibility. Both are essential for flight. By being holographically three-dimensional and including woman, "Universal Man and Woman" completes the sphere and, therefore, the whole message.

Holography is a true art force. It will carry us into new dimensions of vision expansion and reality. It bridges the gap between the two sides of man: technical and psychic. When these two sides of man's nature are in harmony, aesthetic expression flourishes. Holography demands vision, knowledge, and skill, which are traits only found in the holistic mind.

From mind to mind, holography communicates a new dimension of thought. If a desire to create an idea is present, one must find the knowledge or reference to facilitate its creation. The idea is the object, and the source to create it is the reference. As in holography, one must interfere the object beam with the reference beam to create the hologram. Therefore, creation is not self-made.

Holography combines both man's intuitive and technical sides. This brings man into harmony with his true nature, which is both material and spiritual.

Larry Lieberman is the president of the Holographic Research Lab, Columbus, Ohio.

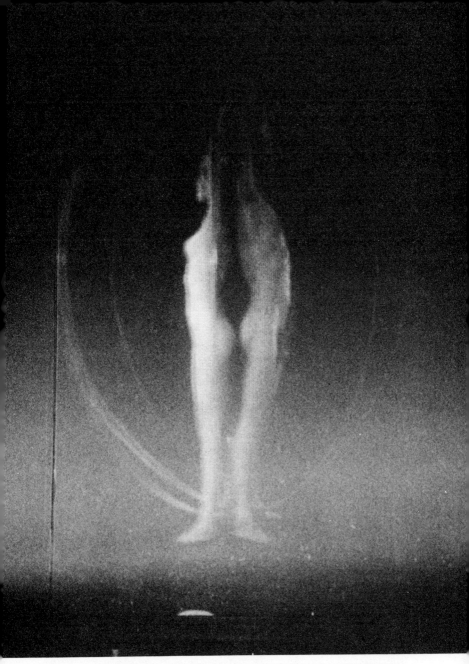

Photograph of 360° integral (motion) hologram UNIVERSAL MAN AND WOMAN, 1976, by Larry Lieberman. Photo © 1976 Larry Lieberman.

Laser jewelry is an uncommon type of hologram. The holographic recording material is not a conventional silver halide film or a photo-polymer, but rather a thin layer of gelatin sensitized to blue light by chromate ions as opposed to silver halide grains. To make these holograms white-light viewable and viewable over a wide angle they are exposed as reflection holograms with the film plane cutting through the image. This means that laser light must be directed through the film from both sides and the standing wave pattern formed by the two beams is recorded as planes of hardened gelatin corresponding to the nodes of the standing wave. Upon subsequent processing in water and hot isopropanal these hardened planes of gelatin are split apart forming partially reflecting mirrorlets spaced one-half a wavelength apart. When white light enters these gelatin layers it is reflected off the mirrorlets in such a way that the wavelengths of light that correspond to the spacing between layers of gelatin are selectively reinforced and reflected with the greatest efficiency. This phenomenon is known as Bragg diffraction and the mirrorlets are know as Bragg planes.

Bragg diffraction reflection holograms can only be made in film with very high resolution (on the order of 4,500 lines per millimeter) to record all the standing wave patterns formed in blue light. Very few recording media have this kind of resolution so that most of this type of hologram have been recorded in a few fine-grain silver halide films such as Kodak 649-F and in dichromated gelatin. Dichromated gelatin is the medium used for laser jewelry, and special precautions must be taken to protect its delicate nature. Unlike the stable silver halide films it can easily be damaged by either moisture or pressure. The Bragg planes in dichromated gelatin can be compressed easily by pressing with any hard, blunt object; they will also collapse almost instantly if water is allowed to collect or condense on them. This kind of treatment leaves a colorless clear film that does nothing but refract the incident light. For these reasons each hologram must be carefully covered and sealed with glass and epoxy-resin before it is handled by moist human hands.

The laser jewel hologram is a second- or even third-generation hologram. A master hologram is made with the object appearing behind the film plane as a virtual image, then a second hologram is made using the pseudoscopic real image of the first hologram as the object for the second hologram. This inside-out inverted image is

obtained by simply tumbling the first hologram end for end, causing the reconstruction beam to impinge on the opposite side of the film plane. The object will appear in front of the film plane rather than behind it, and the second piece of film is then placed at a location in front of the first hologram where the image appears to be partially behind and partially in front of the film. The resulting second-generation hologram is viewed by flipping it end for end, which effectively turns the image right side out, and the object will appear partly in front and partly in back of the film plane.

The color of reconstruction is determined during processing of the film; the first-generation master is made to reconstruct strongly in the blue region of the spectrum. The copies are usually fattened up and made to reconstruct in a broad-band fashion. Strong green holograms are another possibility; purely red reconstructions are much more difficult than blue, green, or broad-band black and white. Several different laser wavelengths are used in the exposure of some holograms to give them more color or extend their color range. The argon laser provides five or six usable lines in the green and blue ranging from .514 to .458 microns, and the He-Cd laser is most useful as a low-power nearly violet source with a line at .442 microns.

Lasers suitable for making reflection holograms in dichromated gelatin are rather expensive. The He-Cd laser is the least expensive at $2,500 to $6,000, and the argon laser may cost $10,000, making this type of holography somewhat out of reach for the hobbyist. Processing is done in hot alcohol, which is in itself an inherent health and accident risk. Very large holograms are impractical because of the size of the required alcohol bath and the necessarily very long exposure times. Very deep holograms will suffer some resolution loss upon reconstruction because of spectral spread of the white-light source. Shallow small holograms are relatively easy to make uniform, bright, clear, and richly colored, qualities that are admired in jewelry.

Many times people have expressed interest in holograms done on ester-base films instead of glass, but cross-linking with the resulting shrinking in the gelatin during exposure has put severe limitations on this process. The results of attempts to do this are usually a darkened area and interference fringes across the finished hologram. The use of glass makes the hologram more delicate but much more impervious to moisture and scratches so that the best possible optical quality can be maintained for the longest period of time. Since there are no chemicals left in the gelatin after

processing, the lifetime of the hologram can be very long and ultraviolet light cannot cause printout or darkening to any extent, as it will with most conventional recording media. These holograms should remain bright and colorful for many, many years.

Electric Umbrella

We at Electric Umbrella are making a variety of small, bright, colorful reflection holograms. All recordings are done in our own finely tuned dichromated gelatin emulsions. Our goal this year is to make a commercial high-quality three-color dichromate; we also are interested in perfecting one of our three different multiplexing techniques. We don't believe our future efforts will be directed toward larger plates or the holographic movies some energetic persons are pursuing. We will be concentrating on good-quality small items in every imaginable jewelry and display application. We already make pendants, rings, earrings, bracelets, tricky-watch crystals, and even business cards. We now have over 150 images belonging to 25 customers or ourselves and we expect to create hundreds of new images in a variety of shapes and sizes.

Rich Rallison is the director of Electric Umbrella, Salt Lake City, Utah.

LOREN BILLINGS

In holography, we are manipulating the medium which forms the information structure of our visual universe, light itself. We are not speaking of objects now, but of what causes an object to be perceived as a physical reality. We are learning how to control the transmission channels and recording mediums. We are working to create spatial memories. We finally have our fingers on the visual field in which we live. We must now study the spatial language of light, and evolve a new realm of visual semantics.

Loren Billings is an active holographer and teacher in the medium. She organized the School of Holography in Chicago, Illinois.

THE "LASERGROUP HOLOVISION" CO.

The company originated in the late sixties with a group of researchers at the Royal Institute of Technology in Stockholm. This group was working with development of laser applications for industry, and interferometry in combination with holography became their specialty under Dr. Nils Abramson's supervision. Holovision Co. started in 1974 to develop commercial holography and Hans Bjelkhagen, M. Sc., has contributed with such outstanding large holograms as "Tomorrow," which is permanently displayed at the Museum of Holography in New York.

Today the company is a daughter company to Dagens Nyheter AB, which in its turn is Sweden's largest media group, owner of Sweden's largest daily papers and a large part of the Swedish film and video industry.

The main two activities are still commercial holography for display and industrial measurement using holography and laser technology. The company has a high R&D budget, is presently developing several techniques where applications have been filed, and has started to organize its marketing efforts.

Hans Bjelkhagen is a principal in the Holovision Company, Stockholm, Sweden. Below: Bjelkhagen making a hologram of the King's Crown at the Royal Institute of Technology, Stockholm, 1974.

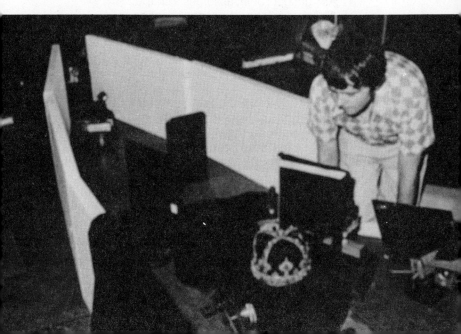

C. B. GAINES

When Gabor made the hologram,
He added to the world of man.
Our future life may be quite bright,
Just like a beam of laser light.

You ask me why I make this claim,
Besides in print to see my name?
May I present this line anew,
The old conception $E = m^{-1}c^2$?

The "E" is Everything, you know,
From N. Ergy to M. Monroe.
The "c" squared stays the speed of light,
But add in phase the laser's might.

For anti-matter ("M" dash one),
Read hologram. Now here's the fun,
As light gets bent; assumes a shape,
An image's formed that can't escape.

A hologram when first you look,
Seems like a page within this book.
But viewed within the proper light,
And space and depth grow very bright.

Take light, just light, to recreate,
A hologram. You see it? Great!
Some think these images appear,
More real than things we see and hear.

And if you say that lasers may
Be all over the world some day,
Then holograms will be there too,
So you may see your dreams come true.

C. B. Gaines is an active holographer in the San Francisco, California, area, and is associated with Holografix, Emeryville, California.

FRED UNTERSEHER

Beyond the beauty of the laser and the ooh and ahh of the three-dimensional qualities of holography, I've found holography seems to have an incredible way of helping people make the leap in their perception and takes them beyond the everyday experience of vision as we know it (i.e., thinking we see objects). What we are really seeing when we look at anything is reflected light, just that, and nothing more. How much time do you spend seeing everything around you as reflected light? It's always there, yet we have come to identify objects as objects, and not as the reflected light that stimulates our senses.

Holography is a much simpler and more creative way of seeing reflected light than going into a room with one light, looking at an object,
turning off the light and looking at the object,
turning on the light and looking at the object,
turning off the light and looking at the object,
turning on the light and looking at the object,
turning off the light and looking at the object,
turning on the light and looking at the object,
until you understand what's going on.

Fred Unterseher is the founder of Holografix, Emeryville, California, and is a holographer and holography teacher.

The coincidental events of Glenn's orbit about the earth and the discovery of the laser I feel have led to an expansion of consciousness akin to the discovery of the telescope and microscope. The exploration of space has led not only to visual knowledge of our unknown universe but also a vision of our planet from outside, aiding a comprehension of global systems that were previously glimpsed only by people of great vision.

The laser facilitated the recording of interference patterns producing a spatial record that has some affinity with internal space of the self perhaps by informing of vision and brain processes themselves. Inherent with the discovery of the telescope and microscope in the Netherlands existed a commitment to aspects of realism which presently seems paralleled with, and helps comprehend the growth of interest in, dimensional reconstruction systems. I have just finished reading a work on solar energy which I liked not because of any brilliant technology, but a tracing historically of the sporadic individuals who pursued knowledge of light phenomena and light control as if mesmerized by the light itself. The three-D imaging conference in San Diego gave the opportunity to sense the diversity of research and aspects of comprehension that the symbiosis of light and sensory systems are creating by understanding the perceptual processes of the human system. The compelling thrust that we have to reconstruct facets of our reality dimensionally has to do with understanding through illusion the tuning of the senses and intuition.

Selective reality is another move from the real-time survival line, like the Eskimos getting tin cans of food to be eaten when required. I have a jackknife and a fountain pen in my pocket. I would like to trade mirrors with the Indians again. A mirror is a refraction illusion; glass a transmission illusion.

Definitely dimensional, but then so is reality, but by the time you go to the other side to check it out you are altered anyway, so either it's an illusion or reality. The ceaseless shifting sensors create an interference pattern themselves, which I am studying. It's impossible to isolate constants or variables. The only evidence is the pattern itself to understand the sources looking back through the aberration, trying to recognize the symbol of transmission that created the synthesis with which you are confronted. Once the sources are recognized or glimpsed, your reconstructed

manifestations evolve related to your own biased sensory equipment. Eskimos were reputed to have the ability to navigate their coastlines by interpreting the wave patterns of the water space beneath them through the skin membrane of their kayaks.

Stereoptic vision evolved through attempts to focus spatially to allay disorientation which is a constant discrepancy to the system of static alignment. The continual regeneration of the present disallows fixed constants within the sensory network. The behavior of light is responsible for visual information. It carries the image through the optics and, symbiotically, the distortion. The quality of its passage is the visually implanted reality. What we see in the mind's eye includes process. Prior to 1900, most visual expression portrayed a static or frozen act conveyed by a stillness inherent in fixed viewing.

The visual sense develops ability to perceive and orient through continual and complex perceptual activity. The visual sophistication gained through the need to orient at greater speeds during the development of the automobile and airplane familiarized us with rapid binocular vision through accelerated linear motion and physical spatial freedom; it created an understanding of vibration and motion effects on the eye. Photochemistry enabled a record to be made of images transmitted by light to sensitized crystals. This changed the time sequence of reality, removing it from the present and introducing a new system for evaluating the degrees of realism in the recorded image: the concept of resolution which uses the eye as its standard. The process for producing recorded images also enabled the images to be placed together for stereo reconstruction, using various optical devices and serial images to create the motion-picture systems. Motion pictures were an attempt to capture greater dimensional reality. Dimensional reproduction systems are the continual endeavor to produce a reality and not a reproduction of reality.

Perceiving reality alters continuously. Perceiving dimensional illusion alters continuously, as the observer is a variable as is each imaging system's bias. The senses operate adjacently by their attention and excitation, producing a synthesis of sensation. Illusion from reality is sensed by what isn't present; a cumulative absence that enhances spatial illusory reality by triggering sensation. A strength of reproducing dimensional images in varying systems is that perception of reconstructed imagery still is dependent on resolution and aberration, eye behavior and integrated brain processes, so that visual communicating systems are distinct one from another by their various inabilities to portray reality and by their

specific illusion-creating quality. The emotive essence of spatial reconstruction is integral with the systems portraying it. The printed newspaper photos' low resolution has often an expressiveness that contradicts the theory that highly resolved images should emote a greater degree of realism. The televised simulated space programs never convey the reality of space the way the distorted transmissions of the actual event do. If holography presently has visual shortcomings, it is due to the high resolution needed to record the interference pattern, which sometimes replaces illusion with the ultra-real. The illusion seems the mystery.

Jerry Pethick is a pioneer holographer whose ideas on the subject have been widely published. He is living on Hornby Island, B.C., Canada.

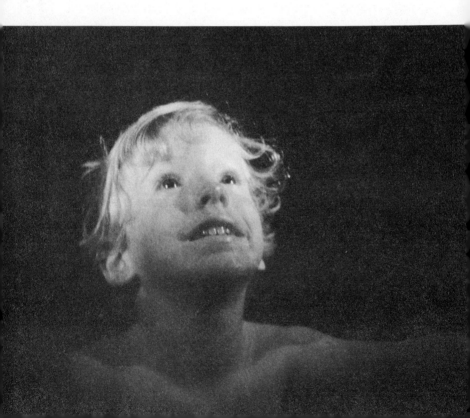

PETER NICHOLSON

"Holography or its mutants will be as important to mankind as was the printing press. It will be one of the cornerstones in man's intellectual evolution."

Peter Nicholson, founder of the Haran Corporation, and a past director of the holography program at the Cooper-Hewett Museum/Smithsonian Institution, has developed a pulsed laser which permits large-scale, deeply dimensional, high-fidelity holograms of live subject matter. Acting to freeze motion like a conventional strobe-light, the pulsed laser emits a powerful pulse of 30 billionths of a second. Nicholson, who has worked with holography since 1967, is the foremost authority on pulse-laser holography, and is currently at the University of Hawaii.

◀ Photograph of pulsed transmission hologram SHAN, 1979 (16" × 20") by Peter Nicholson. Photo © 1979 Kumar Productions.

"No genius has yet arrived to create an art form out of holography," it has been said. "The technology is far ahead of the aesthetic," it has been said. Like most simplistic analyses, these statements reveal a myopia. In reality, the few committed artists working in the medium suffer from a restrictive, at times primitive, technology, being forced to make compromise upon compromise over compromise.

The invention of holography was a technological feat, a scientific breakthrough suggesting unlimited multidimensional expression in light. But in the years since its initial application, the great technological advances claimed for it have been exaggerated. For some of us working in the medium, the state of the technology has failed to keep pace with the state of the art. And not vice versa.

This is not to say that art should abandon the medium to science and industry. Rather, we must continue to work to fulfill the immense possibilities of its special spatial and time properties.

Nor is it to say that no art has been created in holography. Though there may be little of it, to me the problem is more one of educating the viewer or participant to the unique nature of holographic integrity than one of "Is it art?"

"Instant artists" are a problem. Anyone who can make a hologram image is immediately an artist. Not unlike early filmmaking and still photography, the holographic arena is a confused mixture of scientists, hustlers, and the few visionaries or freaks—depending on who is name-calling—dedicated to artistic principles, be it for holography, environment, steel or pencil drawing.

I should have preferred, for this catalog, to have made a visual communication, more consonant with my exhibition, but at this point in the history of holography, I feel acutely the need to state my views in the medium of words.

Freed, which we shall surely be and are ever closer to being, from the limitations of unalterable spectral coloration for reconstructing in ambient light, single-color images requiring darkened environments, miniaturization, shrinking the scale and scope of aesthetic conception, and the expense prohibiting wider access to holographic equipment, I believe holography, along with other technological art media, will be a significant contribution of

our time.

I think holography will be not only a vital art form but a powerful mass medium used in education, the home, theatre, movies, and television. I see holography innovating change in our collective response to the physical and psychological environment.

Further, I visualize a holography appreciated for the mystery and glory of its light, a holography humanized, stripped of technical virtuosity, a medium with which is experienced a free articulation of resonant form.

Harriet Casdin-Silver is a widely exhibited fine-art holographer. She is a fellow at M.I.T.'s Center for Advanced Visual Studies, an instructor in the medium of holography, and one of the first people of either gender to explore it as a fine art.

DAVID HLYNSKY

Day after day, new technologies spring up like crabgrass. Occasionally, like a mythical Zen gardener, an artist turns up claiming to have just discovered an amazing new technology rich with the potential of human expression. The critic, propped up by time-tested examples of real, true, or high art can counter the enthusiasm with a carefully considered "ho hum." The battle that rages between the "alleluias" and the "ho hums" is nothing novel in the history of human exchange. In fact, we've nourished each other that way since the crack of dawn. If "art" is anything, it is the way we carry on that dialogue . . . and if luck has it, a gallery curator has been within earshot of the whole controversy.

Curators are practiced in the fine art of art business . . . the budget proposal, the telephone conversation, and press release. After six months of stamp-licking and a few weeks of poster-posting, the ribbon is cut . . . the switch is thrown. Artists, critics, curators, and the elusive audience meet together for the first time, mumbling and grumbling, ho humming and oo ah-ing. Ra Ta Daaaaa! This year's sparkling contribution to techno-art is born! Like an awkward little robot (still greasy behind the antennae) it takes a small step, points and says its first words . . ."DaDa(!)" . . ."M.O.M.A.(?)" . . . A great sigh ascends buoyantly to heaven. We search our pockets for the parking-lot receipts and wander off full of wonder . . . at least that's the way it goes in fairy tales.

Well, now, dear reader, you've found yourself part of the whole

holographic affair and you might just wonder what it's all about. Let me point out a few subtleties for you. As you enter the gallery please observe a group of small objects (the holograms) surrounded by people doing the "Gawk." Now, the "Gawk" is a kind of bobbing-up-and-down-dancing that you have to do to experience the third dimension fully. It's a basic improvement on the graphic arts . . . light and form are animated in direct response to your own movements. Look at the color, shape, lighting, and sculptural qualities of each hologram. Try to distinguish their similarities and differences. The glossary of terms should help. Keep in mind that you are looking at the works of the first generation of holographers . . . holographers who have come into this discipline from vastly different backgrounds. Some were painters and filmmakers, some physicists. None of them have been born into holography. Laser holography is barely fifteen years old. The holographic "tradition" simply doesn't exist . . . at least not the way that the painting or photographic traditions exist. Precious little history can be written while the past is still the present. While critics ask, "But is it art?" most serious holographers are asking, "What kind of art will holography be?" And that, of course is the question that permeates every piece in this exhibition.

Let's speculate on the future of holography . . . We'll have to develop an easier system of portraiture. There is a system available, but it is too expensive for popular use. Then we will have to develop longer sequences of motion and more accessible viewing systems . . . and a way to mass produce or broadcast holograms. There are serious limits to the possibility of broadcasting as we now conceive it, but then preconceptions are often the entrances to blind alleys. The answers to our most difficult questions are obvious only in retrospect. Every holographer here is gambling on a technological breakthrough that will make holography a more flexible means of communication. "When can we expect holographic theatre?" That's a little like asking, "When can I taste the moon's blue cheese?" Our expectations will be compromised by even more amazing realizations. It will make you scratch your head and rub your eyes . . . and this is only the beginning.

David Hlynsky is co-director of Fringe Research in Toronto (Ontario), Canada. He is a photographer, holographer, and silk-screen artist, as well as an animator. He is widely published, and his work has been exhibited in the United States, Canada, and elsewhere.

ANAIT

A Letter to Leonardo da Vinci

Dear Maestro:

With the greatest respect and admiration I'm writing to you across time and space, in answer to your question "Will they ever—?" Yes, a million times yes!

We now traverse the heavens, to learn more about our sun and its planets; and present-day visionaries discuss the day when we will travel still farther beyond to explore our galaxy. Science is also bringing us to the place where we see space and matter merge into one another, and all is energy!

One most exciting discovery is a beautiful thing to behold—a light whose beam is so pure it startles the eye. The colors are more brilliant than a hundred rainbows! It can beam as strong as our sun, or as gently as a distant star. It is called laser light. With it so many things are possible. It can be made as delicate as the finest scalpel for surgery; and it can be made powerful enough to create energy by fusing the invisible stuff of matter called atoms.

As a sculptor fascinated by science and new materials with which to experiment, I have used resins clear as glass, to form and sculpt. Then there were sheets of film, brighter than polished mirror; there were colored lights gleaming like stained-glass windows in the sun, and then there was the laser light! It made possible the capture of reflections of an object—nay, the space in which an object may or may not be, on an invisible film of silver. The waves of laser light that ripple through the space to the film are then darkened with solutions. This darkened film has caught forever that time and space in its true dimensions, and will divulge its secret information only when shone upon with a beam of light shining from the same direction. But! If the light is shone from the opposite—on the back of the waves—the information is reversed completely, like an empty purse turned inside-out, except—the outside is still the outside! What mystery! What joy to be able to capture space and forms in light and put them in reverse dimension! The eye has never before seen such things. Holography is its name, from the Greek word *holos,* meaning "whole." For the first time in our human history we can record information with its true dimensions; we have gone beyond

the traditional symbol on the flat surface!

This is truly an exciting time to live; I'm sure you would find it inspiring. Wish you were here!

<div align="right">With sincerest regards,
ANAIT</div>

Anait is an artist whose explorations of almost every artistic medium has led her to become one of the best-known fine-art holographers. She has been widely exhibited. She lives and works in Santa Barbara, California.

PETER van RIPER

Holography is a complicated subject to ask me about, many associations. I returned from Tokyo University to Ann Arbor in the early sixties and met Lloyd G. Cross. We had a corporation doing very early holography. That work led to an exhibition at Cranbrook Museum of Art of an environment piece with krypton laser and holograms.

In 1970 we were in California. I taught holography at the California Institute of the Arts and Lloyd and Jerry Pethick were in San Francisco; I joined them there three years later. I'm living and working in New York City but we all still also work together.

As an artist, my interface with holography and laser technology is always aimed at achieving a particular art piece that communicates the concerns of all my work. They are chance, change, it-ness, attention; a concern with perception.

Some holograms of particular interest (I love the process for its awareness-raising and feel the many 4 × 5 holograms made were special) are: 18 × 24 transmission plate of Duchamp "readymade" bottle dryer; holographic glasses made while artist-in-residence at Japan Electon Optics Lab; "Rainbow Man," 18 × 24 plate for sunlight illumination; "Rainbow Rock," white light reflection inter-stage for color silk-screen piece; and some unusual multiplex holograms.

"Room Space" I and II I call peripheral multiplex holograms. Peripheral by dictionary definition is "outside of; external (as distinguished from central)." In "Room Space," the room outside of the room light image in the multiplex completes the piece.

Peter van Riper is an artist using various media, among which holography is of major importance. He lives in New York City.

VINCE DI BIASE

The Human Side of Holography

The process of thinking may be holographic in nature. Looking at holograms is seeing with the mind's eye. A three-dimensional (visual) thought-form. Seeing . . . "inside the bubble of our primal Being, listening to the echoes of an almost forgotten Unity."* Cut a corner off a hologram. Look at it. You will see the entire image from the original hologram . . . just as the little bit of spirit within each of us is holographic in nature. *Genesis.

Vince di Biase works in holographic "multi-dimensional light sculptures" which he calls "Chromagrams." His studio is in Larkspur, California, near San Francisco.

Photograph of ROOM SPACE I, a 360° integral hologram, by Peter Van Riper. Photo © 1978 Peter van Riper.

DAVID A. GOODMAN

How an Age of the Hologram might come about: We rediscover what Jolande Jacobi told Miguel Serrano in Zurich. "Nineteen sixty-four," she said, "in that year, the world moves from one epoch to another. The coming of Christ coincided with the beginning of the present age, Pisces, which is now nearing its end."

Referring to the feelings of the great psychologist/mythologist of Zurich, she said, "Jung is very much afraid." Perhaps a war or catastrophe might take place in the year 1964. But quite the contrary, as we now know, the opening year of the Age of Aquarius was a most exciting one for holography.

It was the year the first Leith-Upatnieks holograms were shown to the public; optical computing emerged from the writings and research of professor Stroke; holographic spatial filtering was Vander Lugt's invention; and in the work of Greguss and Brendon we had the first glimmerings of the acoustic hologram.

Consider the hologram as most appropriate to the Aquarian Age. It is formed by the interference of waves on the surface of still water. Viewed with a laser, the acoustic image seems to bob above the surface as a spirit rising through the meniscus. In acoustic holography, as some disciples of C. G. Jung may have already discovered, we have the mandala of the new epoch which is, as Jolande Jacobi never told Miguel Serrano, an emerging Age of the Hologram.

David A. Goodman, Ph.D., a founder of the Newport Neuroscience Center (Culver City, California), is a neuroscientist and holographic theorist.

SUSAN HOUDE

Holographers: We want YOU!

Our bookstore is always looking for brilliant new imagery. Operating from the world's only official holography museum, we meet more people interested in holograms than anywhere else—and they want to take them home! We sell reflection plates, integrals, rainbows, dichromate jewelry, flat integrals, and more. If you have production capability and truly excellent images, send us a sample and price breakdown, or drop us a line at the address below.

On the other hand, we sell a complete line of books on holography, light and color, applications, and technology for both holographers and the lay public. We also sell elegant displays for 360-degree and 120-degree integrals, 4 × 5-inch reflection plates, flat integrals, and white-light transmissions.

Feel free to request our catalog—just write to:

The Museum of Holography Bookstore
11 Mercer Street
New York, N.Y. 10013

or call: (212) 925-0581.

Susan Houde is a New York City holographer, and is the manager of the bookstore at the Museum of Holography, New York City. Below: Lee Zemann at the Bookstore counters, Museum of Holography, NYC.

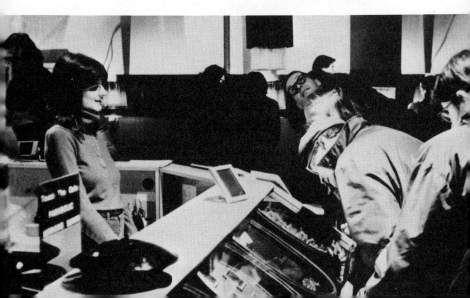

Holography is perhaps the most revolutionary visual recording medium since the prehistoric cave paintings at Lascaux. For the first time in the history of literate man, we can communicate through a medium which has the same dimensional properties and characteristics as the world in which we live. This is a radical change from the Lascaux/Gutenberg tradition of visual literacy which depended on a strictly two-dimensional reality—a reality, in the West, firmly grounded by a bordered left-to-right, top-to-bottom pattern of seeing. The eye was always focused on one plane—the flat surface (substitute dirt, page, wall, canvas, plate, film, television or movie screen, videotape, microfiche, etc.)—and had only to recognize the flat patterns of letters (symbols), forms, and other linear imagery. The eye had only one visual path to follow.

These same two-dimensional compositional techniques used in the earliest communication arts were adopted by the later media of photography, film, video and television. These highly innovative, modern communications media still rely on the left-to-right, top-to-bottom read-out system. Theirs is still a flat, bordered, two-dimensional reality. Even though each medium can depict dimension, volume, and space, they still record it as two-dimensional information and play it back on a flat plane with a fixed perspective and fixed imagery. The reason these new media can successfully rely on older visual traditions (techniques) is that these new ones are fundamentally no different in the way they process information from the old and can thus use the same visual alphabet to spell out the same objectives: giving meaning, focus, and emphasis to static information. This has been the status quo for visual recording communications for hundreds and hundreds of years.

Enter Holography

Holography is an extremely sophisticated, complexly informational medium. It represents the space in front of and behind the plane of traditional visual recording. It is the cube rather than the square. Holography is revolutionary because its form (content) breaks away from every aspect of our present visual traditions:

Holography does not have a bordered, two-dimensional reality where images exist in static relationship to each other, in a flat perspective that can only be seen from one fixed (given) view. Holographic images exist in real space, and are themselves totally three-dimensional. Objects in holograms can be viewed from many angles and, in fact, appear in changing relationship to each other when viewed from different positions. Holographic images exist in their own space which exists in real space (as space). It is sometimes very difficult to tell where one volume stops and the other begins. (That doesn't imply that there is unlimited volume to work with, only that the given amount has no defined edge and thus seems to exist in unrestricted space, unlike the canvas, screen, page, or monitor, which are bordered by their own extremities.) Holography is, literally, a whole new dimension in visual communications.

Look at That

Holography is changing the course of visual literacy because it is forcing us to reevaluate our visual traditions in order to deal with it (use it effectively). For instance, on the most basic level, you don't look at a hologram—you look into it. A holographic image can project in front of the plate (a real image), in back of the plate (a virtual image), or it can straddle the plate (an image plane). Several images can exist in any number of combinations of positions relative to the film plate.

Holography is dominated by space (volume) and perspective (dimension). Yet, all our common visual materials and techniques were created for two-dimensional media. How does holography represent a dot? Or a line? Or a graph? What does the side of an "a" look like? Can we recognize its side since we are only familiar with its frontal view? Holography has no such frontal, fixed view. Imagery cannot be created for holography as it has been for the old, flat-surfaced media. Holography gives its imagery a side, a top, a bottom, visibility from many angles, and the ability to be many different compositions at the same time.

Our two-dimensional interpretations of reality actually become reality with holography. Dimension, perspective, scale, and proportion physically exist in holography. Balance, symmetry, direction, and thrust are no longer academic decisions; they are sculptural ones. Those elements which are the language of

expression—color, line, texture, shape, and scale—have different roles in a three-dimensional arena. How much of the old content can be put into this new form? Does it then carry the same meaning? Or does holography demand new forms? New visual traditions? Clearly, we have to educate ourselves concerning the new expressive power of three-dimensions just as we taught ourselves to read and write for print.

The Whole Message

Holographic images have all the same physical qualities as their real counterparts, except that they are made up of points of light focused in space. (A magnifying glass used as an image in a hologram really magnifies an object placed behind it.)

Holographic images are recorded so accurately in size, dimension, volume, and space that they are used to test and measure minute stress changes in objects (interferometry). Holographic images are actually recorded in accurate microscopic detail. (A hologram of a glass of water, viewed under a microscope, reveals the organisms in the water in their natural three-dimensional state, even though they were not visible to the naked eye.)

Holography can also express space from a variety of unique viewpoints. For instance, a hologram can include three-dimensional multiple exposures and superimpositions of imagery (volumes)—in space! One hologram can contain several different "channels." Each is viewable from a different angle and each occupies the total holographic space with its own imagery and at its own angle.

A hologram can consist of several other holograms, used as objects within the larger hologram but having their own imagery and space within the larger space. To my knowledge, this technique of "pockets" of space within larger pockets of space is unique to holography and unreproducible in nature.

A hologram can be viewed inside out and backwards (pseudoscopically) just by turning it back to front. This unique perspective is like being inside the imagery looking out to where the viewer normally would be.

One of the most fascinating qualities of holography is the medium's ability to modulate time (time in space). Because holography records reality as a total three-dimensional volume of "activity," it has the effect of encapsulating time. It is as if a hologram

is a record of a space of time, or a time in space: a precise moment which can be recalled exactly as it existed when the recording took place—when it "happened." (Many people believe that holography is the brain's memory-storage mechanism).

This "time capsule" quality is particularly evident in holographic imagery recorded with a pulsed (as opposed to a continuous wave) laser. (A pulsed laser stops action in holography in much the same way a strobe unit does in photography.) Pulsed holography has produced startling ways to look at familiar imagery. Frequently, the message of the imagery becomes so distorted by the stop-action (isolation) that the image takes on a totally different meaning and reality: cigarette smoke becomes a gauzy water hanging frozen in space; poured water loses its direction key and becomes a column connecting its container to a hand like a walking stick to its handle.

Holography is definitely an apt instrument with which we can enlarge our perceptions and conceptions of reality. It is truly a window, held up to a particular vision of reality, and it demands a new way of seeing—a new set of reactions to its visual imagery.

There are, to be sure, many problems and drawbacks with state-of-the-art holography. Imagery cannot be illuminated with natural light for recording (a laser has to serve as the only light source). Holographic equipment is delicate, complicated, expensive, and generally unavailable to the artist. There is no really effective system for producing holographic images in full (natural) color. Imagery can only be viewed by looking through the holographic film, thus limiting the size of the imagery as well as the audience. Holograms cannot, as yet, be viewed in any light or from any angle. But these are all drawbacks of time, here because this is the beginning.

Holography, like most technologies and all art forms, is a true craft. It is, at the moment, still in the process of becoming. Sometimes imagery which is meaningful, appropriate, or effective is abandoned for what is possible, easy, and available. In the past, more often than not, holography has expressed its limitations rather than its potential. This is slowly changing as we learn to create rather than merely copy reality, as technology catches up with imagination. Even now, holography expands our ability to see, which, in turn, expands our world.

The Space Age

For the first time in the history of literate man, we are able to communicate through a medium which has the same dimensional properties and characteristics as the world in which we live. Think about it. If we have been brought (educated) to this point, if we have advanced *this* far with two-dimensional communication/information (reality), where will we be after a lifetime of holography? And our children, who will grow up with holography the way we grew up with television—where will holography take them, and their children? (To yet another dimension?)

All we know is where we are—now: welcome to the beginning of the voyage.

Rosemary H. Jackson is the founder and director of the Museum of Holography, New York City. The text reprinted above is from the catalog for the museum's inaugural exhibition, "Through the Looking Glass," in 1976. She is herself an accomplished holographer.

Single frame from original cine film for KISS II, 1974, 180° integral (motion) hologram by Lloyd Cross. Photo © Multiplex Company

POSTSCRIPT

Words reflect space. After looking at holography from a number of perspectives, and discussing it in a variety of languages, various impressions have accumulated in one's mind about holography. But the essential question must come at the end of the overview, in order that those who enter the medium at whatever level they choose may be reminded that as holographers, scientists, entrepreneurs, artists, authors, critics, or spectators, all have a historically unique opportunity to create individual responses to a genuinely fresh question: What is holography?

The following list of galleries, courses in holography, holographic laboratories, equipment suppliers, recommended readings, and other resources is not comprehensive, but will easily cover most requirements for holographers in the United States. There are also a few resources listed in various other countries.

GALLERIES

FASHION MODA, 2803 Third Avenue, Bronx, New York, 10455. Stefan Eins and Hector Ortega, directors.

FRINGE ELEMENT, 2727-D Routh Street, Dallas, Texas, 75201. Kathleen Mark Bardell and Bob Bardell, proprietors.

GALLERY 1134, 1134 West Washington Boulevard, Chicago, Illinois, 60607, (312) 226-1007. Hours: 11 a.m. to 6 p.m. daily except Monday. Loren Billings, director.

HOLOS GALLERY, 1792 Haight Street, San Francisco, California, 94117, (415) 668-HOLO. Hours: Noon to 6 p.m., every day except Monday. Gary Zellerbach, proprietor.

HOUSE of HOLOGRAMS, 29291 Southfield Road, Southfield, Michigan, 48076. Lee Lacey, proprietor.

LASER LIGHT CONCEPTS, LTD., 57 Grand Street, New York, New York, 10013, (212) 226-7747. Hours: 1 to 6 p.m. Thursday through Sunday (appointments preferred). Abe Renzy, president.

MAINHOUSE GALLERY, 9A Sawmill River Road, Yonkers, New York, 10701, (914) 476-7317. Hours: 10 a.m. to 6 p.m. weekends. Roger Delano, director.

MUSEUM of HOLOGRAPHY, 11 Mercer Street, New York, New York, 10013, (212) 925-0526. Hours: noon to 6 p.m. Wednesdays through Sunday; Thursdays until 9 p.m. Rosemary Jackson, director.

NEW REALITY HOLOGRAPHICS, 4910 McPherson Avenue, St. Louis, Missouri, 63108, (314) 367-2280. Hours: By appointment only. Morrie Maltzman and Billy Citrin, principals.

ODYSSEY IMAGE CENTER, 8853 Sunset Boulevard, Hollywood, California, 90069, (213) 652-0983. Hours: 3 p.m. to 3 a.m. daily. Robert Christianson and Robert Hollingsworth, directors.

SIRENS of LIGHT (in Goodies Warehouse), 200 Second Avenue, Nashville, Tennessee, 37219. Phil Kreger and Tom Drake, founders.

COURSES IN HOLOGRAPHY

New York:

Dolgoff Holophase, Inc.
11 Hillside Avenue
New York, New York 10040
Eugene Dolgoff
(212) 569-7711

Laser Light Concepts, Ltd.
57 Grand Street
New York, New York 10013
Abe Renzy
(212) 226-7747

New York Holographic Labs
34 West 13th Street
New York, New York 10011
Dan Schweitzer and Sam Moree
(212) 242-9774

Sapan Engineering, Inc.
245 Seventh Avenue
New York City, New York 10011
Jason Sapan
(212) 255-5995

Chris Sedlmayr
70 Greene Street
New York, New York 10013
(212) 925-4224

California:

Celestial Holograms
56 Hillcrest Court
San Anselmo, California 94960
Lon Moore
(415) 296-3360

Holografix
1420 45th Street
Emeryville, California 94608
Fred Unterseher
(415) 658-3200

Randy James
30 Winfield Street
San Francisco, California 94110
(415) 282-8909

School of Holography
550 Shotwell Street
San Francisco, California 94110
Lloyd Cross
(415) 824-3769

The Multiplex Company
454 Shotwell Street
San Francisco, California 94110
(415) 285-9035

Florida:

Holografix
7250 Southwest 126th Street
Miami, Florida 33156
Mark Diamond
(305) 235-1929

Illinois:

Lake Forest College
Physics Department
Sheridan and College Road
Lake Forest, Illinois 60045
Dr. Tung H. Jeong
(312) 234-3100

Britton Zabka
Harrison R.R. 1
Charleston, Illinois 61920

Michigan:

Lee Lacey
29291 Southfield Road
Southfield, Michigan 48076

Canada:

Fringe Research
1179 A King Street West
Toronto, Ontario M6K 3C5
David Hlynsky and Michael Sowdon

France:

Jean Sagaut
Le Parnassium 18
28 rue Labrouste
75015 Paris
Tele: 532-49-23

Netherlands:

Europlex Holographics B.V.
Singel 38, Postbus 1860
Amsterdam
J. Barrie Boulton
Tele: 020-226-35

Sweden:

Lasergroup/Holovision
Sandhamnsgatan 25
S-11528 Stockholm

LABORATORIES PROVIDING SERVICES FOR HOLOGRAPHIC
MOVIEMAKING

Burton Holmes
8853 Sunset Boulevard
Hollywood, California 90069
(213) 652-0970

Dolgoff Holophase, Inc.
11 Hillside Avenue
New York, New York 10040
(212) 567-7432

Europlex Holographics B.V.
Singel 38, Postbus 1860
Amsterdam, Netherlands
020-226-035

Harold Friedman Consortium, Inc.
Suite 2716
420 Lexington Avenue
New York, New York 10017
(212) 697-0858

Holographic Arts Company
Suite 1149
10 LaSalle Street
Chicago, Illinois 60603
(312) 782-4163

Holographic Development Corp.
5913 Blackwelder Street
Culver City, California 90230

Holographic Film Company, Inc.
361 West Broadway
New York, New York 10013
(212) 431-3170

Holographic Image Systems
1917 Hyperion Avenue
Los Angeles, California 90027
(213) 663-4508

Holovision International Corp.
5610 La Palma
Anaheim, California 92807
(714) 996-2870

Laser Light Concepts, Ltd.
57 Grand Street
New York, New York 10013
(212) 226-7747

The Multiplex Company
454 Shotwell Street
San Francisco, California 94110
(415) 285-9035

New Reality Holographics
4910 McPherson
St. Louis, Missouri 63108
(314) 367-2280

The New York Art Alliance
34 West 13th Street
New York, New York 10011
(212) 242-9774

Sapan Engineering Co.
245 Seventh Avenue
New York, New York 10011
(212) 255-5995

Three Dimensional Imagery, Ltd.
3703 Waaloa Way
Honolulu, Hawaii 96822
(808) 988-2208

OPTICAL SUPPLIES AND LASERS

American Laser
3571 W. North Temple
Salt Lake City, Utah 84122

Apollo Lasers
6357 Arizona Circle
Los Angeles, California 90045

Coherent Radiation
3210 Porter Drive
Palo Alto, California 94304

CW Radiation
101 Zeta Drive
Pittsburgh, Pennsylvania 15238

Gaertner Scientific
1201 Wrightwood Avenue
Chicago, Illinois 60614

Jodon Engineering
145 Enterprise Drive
Ann Arbor, Michigan 48103

Korad Division of
Hadron, Inc.
2520 Colorado Avenue
Santa Monica, California 90404

Lexel Corp.
928 E. Meadow Drive
Palo Alto, California 94303

Liconix
1400 Steirlin Road
Mt. View, California 94043

Metrologic Instruments
143 Harding Avenue
Bellmawr, New Jersey 08030

Newport Research Corporation
18235 Mt. Baldy Circle
Mountain Valley, California 92708

Spectra Physics
1250 W. Middlefield Road
Mountain View, California 94040

KITS AND COMPONENTS

Ealing Corporation
2225 Massachusetts Avenue
Cambridge, Massachusetts 02140

Edmund Scientific Co.
150 Edscorp Building
Barrington, New Jersey 08007

Holografix
1420 45th Street
Emeryville, California 94608

Spindler & Hoyer KG
Konigsallee 23
D-3400 Gottingen
West Germany

*Detailed plans for the isolation table and information on other
equipment shown in the "Doing It" chapter:*

School of Holography
550 Shotwell Street
San Francisco, California
Lloyd Cross
(415)824-3769

RECOMMENDED READING

"The Amateur Scientist," *Scientific American,* September 1964, December 1965, February 1969. On building your own helium-neon and argon lasers.

Brain/Mind Bulletin, Frontiers of research, theory and practice
Marilyn Ferguson, editor
P.O. Box 42211
Los Angeles, California 90042
(213) 257-2500
A bi-weekly newsletter at the growing edge of new-age studies in science and the spirit: Brain function, nutrition, biofeedback, neuropsychiatry, parapsychology, electrical and magnetic fields, perception and memory, etc. $15 per year.

Holography in Medicine
P. Greguss, editor
Papers from the International Symposium on Holography in Biomedical Sciences. Holography as a diagnostic tool; as a model for biological concepts, etc. Contact the Museum of Holography Bookstore, New York City.

holosphere, the newsletter of holographic science, technology and art
Ed Bush, editor
11 Mercer Street
New York, New York 10013
(212) 925-0581
For "people engaged in the application, manufacture, design, development, research and appreciation of holographic systems, devices, components, displays and accessories." Monthly issue. $45 per year; $25 per year with Museum of Holography membership.

Museum of Holography Newsletter
Rosemary Jackson, editor
11 Mercer Street
New York, New York 10013
(212)925-0526

Issued primarily to members of the museum. Inquire about single copies.

A Study Guide on Holography, by Dr. T. H. Jeong, under the auspices of the American Association for the Advancement of Science, 1975. Available at the Museum of Holography Bookstore, New York City.

"White Light Holography," by E. Leith, *Scientific American,* October 1976.

Who's Who in Holography, an annual compilation available through the Museum of Holography, New York City. An up-to-date list of approximately eighty active holographers in the arts, many more in the sciences, and about fifty companies in the field.

HOLOGRAPHY ON FILM

An excellent short film, "Introduction to Holography," is available through Encyclopedia Brittanica films, or through the Museum of Holography Bookstore, New York City.

VARIOUS OTHER CONNECTIONS

Electric Umbrella
3488 E. 7590 South
Salt Lake City, Utah 84121
(801) 942-2065
High-quality holographic (dichromate) jewelry.

Fringe Research
1179 A King Street West
Toronto, Ontario M6K 3C5, Canada
Exhibitions, fine-art holography studios.

The Holex Corporation
2544 West Main Street
Norristown, Pennsylvania 19401
(215) 539-0828
Viewers, filters, transmission and white-light holograms,
dichromates, "decorator" lasers. Extensive catalog.

Holographic Research Lab
30 Latta Avenue
Columbus, Ohio 43205
(615) 258-9371
Custom integral holograms and displays for sales promotions. "It is
impossible for us to know what the future holds in store for
holography, just as it would have been impossible for Gutenburg to
predict 'The Book of the Month Club,' or Edison to forsee Rock and
Roll. So ask yourself what can you do with holography?"

Integraf
P.O. Box 586
Lake Forest, Illinois 60045
Holographic film and plates, holograms, etc.

Bob Schinella
118 Spring Street
New York, New York 10012
Commercial holographic designer, consultant.

COHERENT LIGHT

Light composed of waves of equal frequency and amplitude. (Ordinary, "incoherent" light, such as that of the sun or an incandescent light bulb, has waves and amplitudes of many kinds, and is therefore composed of many colors: white light.)

HOLOGRAM

A recording of a three-dimensional wave-front which has been created by bouncing a diffused beam of laser light off an object. The light from that object intersects (interferes) with another beam of diffused laser light. Where the two different beams intersect is the wave-front.

HOLOGRAPHY

A recording and display process which faithfully reconstructs in light the exact contours and dimensions of three-dimensional forms.

IMAGE-PLANE HOLOGRAM

A hologram in which the image appears to be extending partly in front of and partly behind the film plane.

INTEGRAL HOLOGRAM (WHITE LIGHT)

A holographic method of recording a motion picture on a piece of 120° or 360° holographic film wrapped in a circular curve inside a clear Plexiglas cylinder display unit. It is reconstructed by a vertical-filament light bulb mounted below the cylinder. Some displays are motorized to turn the cylinder; others require the viewer to move in order to create the illusion of motion. The image appears in the space in the middle of the display cylinder. (The white light integral hologram is also known as a Multiplex or an integram.)

INTERFERENCE PATTERN

When two (or more) coherent waves intersect or "interfere" with one another, an interference pattern occurs. Commonly experienced outside of holography, interference patterns are seen in the graphic arts by the name of Moire patterns. Also, when two stones are dropped simultaneously onto the surface of a pond, where the concentric circles of ripples cross each other, an interference pattern is created. In making a hologram, the first thing the holographer does is set up an interferometer test.

LASER

The word is an acronym for Light Amplification by Stimulated Emission of Radiation. Lasers create spectrally pure beams of coherent light.

REAL IMAGE

The reconstructed holographic image which appears to float in front of the holographic film plane, between the plate and the viewer. (See: virtual image.)

REFLECTION HOLOGRAM

A hologram recorded by transmitting a laser beam through the front of the holographic plate to illuminate the image behind it. The term also applies to the reconstruction of a hologram by reflecting a white light off the front of the plate.

TRANSMISSION HOLOGRAM (LASER)

A hologram made (recorded) by transmitting one part of a laser beam onto the object being holographed, and the other part of the beam onto the film plane. A transmission hologram is reconstructed (played back) by transmitting light through the back of the hologram.

TRANSMISSION HOLOGRAM (WHITE LIGHT)

A second-generation hologram which can be reconstructed by a white light source from the rear of the film plane, using an ordinary light bulb.

VIRTUAL IMAGE

The reconstructed holographic image which appears behind the holographic film plane.

WHITE LIGHT

Light which appears colorless, or achromatic. White light contains all wavelengths of the visible spectrum, such as that transmitted by an ordinary light bulb.

AUTHOR'S NOTE

Because *The Holography Book* is a preliminary overview of the wide-ranging and ever-growing field of holography, readers who have questions on any aspect of the subject are invited to address them to the author in care of the publisher, Avon Books, 959 Eighth Avenue, New York, New York, 10019. They will be answered or forwarded appropriately.

Holographic artists and scientists are likewise invited to contribute further information, as it develops, for subsequent editions of, or sequels to, the present volume.

J.B.